AMONG TREES

AMO

SEAN KERNAN
Introduction by Anthony Doerr

ARTISAN
NEW YORK

For Cathy
with Thanks
+ hope!'s

[signature]

NG TREES

Published by Artisan
A Division of Workman Publishing, Inc.
708 Broadway
New York, New York 10003-9555
www.artisanbooks.com

Library of Congress Cataloging-in-Publication Data

Kernan, Sean.
 Among trees/by Sean Kernan.
 p. cm.
 ISBN 1-57965-222-0
 1. Photography of trees. 2. Kernan, Sean. I. Title.

 TR726. T7 K47 2003
 779'.34—dc21
 2002038442

Printed in Italy

10 9 8 7 6 5 4 3 2 1

Book design by Nicholas Caruso

I PAUSE ON A WIND-RIPPED SLOPE OF BIG SUR. A Monterey pine leans out over the Pacific, making a ledge for the sunset. The pummeling gales have strangled its twigs and branches on the upwind side, and it looks like a shaggy black finger pointing out to sea. People pull up in cars, get out, stand and stare. Nothing needs to be said. We all understand the visual nourishment we share. We nod to one another. The cottony blue sky and dark-blue sea meet at a line sharp as a razor's edge. Why is it so thrilling to see a tree hold pieces of sky in its branches, and hear waves crash against a rocky shore, blowing spray high into the air, as the seagulls creak? Of the many ways to watch the sky, one of the most familiar is through the filigree limbs of a tree, or around and above trees; this has much to do with how we actually see and observe the sky. Trees conduct the eye from the ground up to the heavens, link the detailed temporariness of life with the bulging blue abstraction overhead. In Norse legend, the huge ash tree Yggdrasil, with its great arching limbs and three swarming roots, stretched high into the sky, holding the universe together, connecting earth to both heaven and hell. Mythical animals and demons dwelt in the tree; at one of its roots lay the well of Mimir, the source of all wisdom, from which the god Odin drank in order to become wise, even though it cost him the loss of an eye. We find trees offering us knowledge in many of the ancient stories and legends, perhaps because they alone seem to unite the earth and the sky—the known, invadable world with everything that is beyond our grasp and our power.

—DIANE ACKERMAN *A Natural History of the Senses*

A WOODS IN WINTER: Snow falls in big, aggregate flakes, wide as your hand—this is sound-obliterating snow, light-carrying snow. Absolving snow. You look up into the treetops; maybe you try to see the depthless place from where the snow comes; maybe you pick an individual crystal and try to watch it fall all the way into your palm. Behind you, through the trunks, through the noiseless flakes, you can just see the shapes of your tracks. Ahead the trail is unbroken and white. A crow sails past, calling, and is gone.

This, more than anything, is winter: snow limning branches, the hush of sleeping trees.

Every spring, without fail, I watch our bare maples and wonder—what if this year the leaves don't come back? What if there's some unpredicted glitch in photosynthesis? What if the trees stand naked all summer long, no leafy shade, no apples in the orchards, no cottonwood seeds swirling through the yard?

Spring always happens, of course, thank God—it will have been happening long before we began to doubt it: the buds crammed all winter in their little bronze chests, waiting to unfold.

"Isn't it plain," the poet Mary Oliver asks, "the sheets of moss, except that they have no tongues, could lecture all day if they wanted about spiritual patience?" Consider the Spanish moss (the light positively *pouring* through it) in Sean Kernan's photograph of a Louisiana live oak. Doesn't it ask the same question? Aren't a hundred miracles, of patience, of fortitude, implicit in that one image?

Trees have everything to do with faith. Think of druids worshiping the oaks of ancient England; think of Sakyamuni, founder of Buddhism, who discovered the meaning of life by "distilling" himself beneath a sacred fig. Pagan gods lived in hawthorns; Teutons believed pines were their ancestors; many Hindus still believe that every single tree has its own deity.

Were they—*are* they—wrong? We knock on wood to ward off bad luck; we speak of "family trees" and "forbidden fruits." Most of us, at some point in our lives, have entered one of those secret, unnamed places in a forest, where the light changes and the birds go quiet and the passage of time seems to slow. Sean Kernan certainly has: in China, in England and Greece, in Hawaii. His parallel rows of coconut palms in the San Joaquin Valley are the flanking pillars in a church's nave; they are pilgrims awaiting benediction.

So often Kernan's images of trees lead our eyes toward sky: Branches become bridges; trunks become conduits to heaven. And why not? Trees have always been so generous to us, munificent beyond measure, too generous, perhaps, for their own good. In nearly every terrestrial ecosystem, trees are the bones, flesh, and genetic pool—they are houses for birds, cities for insects, playgrounds for light. They make the soil and the oxygen, the noise and the silence. Think of all their gifts: lemons, bananas, canoes, swings, your Kleenex, your kitchen floor, the heat in your fireplace, the pages of this book, even the marker, perhaps, that will stand over your grave.

All this and they are basically defenseless to us—their thorns immobile, their wood yielding. Emily Dickinson called them "the trusting woods, the unsuspecting trees," and they are—they will always be. In a strange and awful way, the survival of every single tree is dependent upon our clemency.

Look at Kernan's olive groves; look at the swaths of clear-cuts in Washington's Olympic Peninsula.

This book is not a whitewashing, a presentation of a mythic natural world that no longer exists. We see the dazzling, unpeopled glory of Oahu's rain forest, yes (and by implication that misty, primordial era, dank and rich, when most of the places we now live were lands of giant, mossy trunks, huge dragonflies spiraling through the undergrowth, a time when the trees were the only giants, rulers of

the world), but we also see the trim paddocks of England's Lake District, a high-voltage tower dwarfing a thin line of Italian cypress.

Indeed, Kernan is careful to present trees across the panorama of their existence: in forests as well as fields and parks, beside buildings, in orchards. We see the deep, pristine groves of Maui, the cathedral redwoods of northern California, but also cultivated rows of pulp trees, a worn harvesting ladder propped against an olive, a palm's shadow on a Los Angeles building. We see Central Park, that paramount juncture of tree and edifice.

These images present another gift of trees, too: They offer a different understanding and measure of time. Walk enough among Kernan's trees and your sense of time will gradually erode—entering the spaces between them is like entering another medium, someplace where a mechanical, divisible, objective understanding of time makes no sense. Seasons matter, and daylight, but seconds and hours are nothing. What is a Thursday to a tree? What is a lunch appointment?

In the sweep of a branch, in the surprising swerve of a trunk, in the convulsed mayhem of exposed roots, we see wind, frost, parasites, drought one year, flood the next. We see human signs too—pruning, the removal of diseased limbs, even the stunting of air pollution. Trees tell stories if we listen closely enough. Distill yourself beneath one and you might just hear the meaning of life.

There is another generosity of trees, of course, another gift of this book, and that is how trees allow us to experience light. Trees have everything to do with light— why else, really, do so many of us wrap trees in strings of bulbs each December?

In a book called *Space and Sight*, Marius von Senden tells us about a girl, blind since birth, who is given her sight back by a cataracts operation. The doctor brings her to a garden and notes: "She stands speechless in front of the tree,

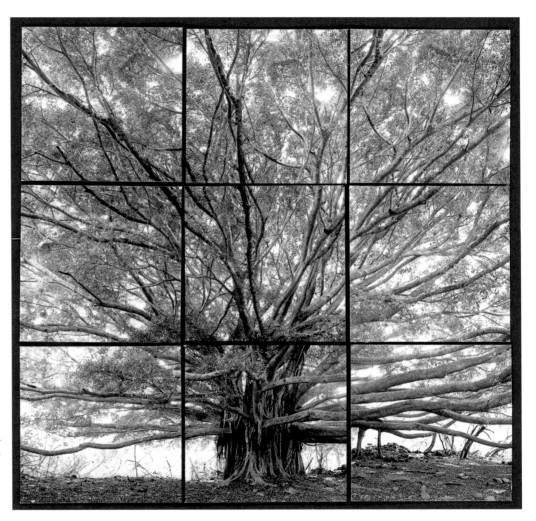

which she names only on taking hold of it, and then as 'the tree with the lights in it.'" Edward Hoagland, as he was going blind, wrote: "The platinum light of the early morning, as a gentle rain fell, nearly broke my heart—the tiers of green, each subtle shade different, ash from cedar, spruce and apple, lilac, locust, and dogwood—leaves whose beauty I was losing." This, more than anything, is what Kernan's photographs offer us: an invitation to stop and simply *see*—to let these images enter us, alter us. On every page there is a tree "with the lights in it."

In a sense, trees are the ultimate photographic subject, because what is photography if not a study of light? And what are trees if not arbiters of light? Absorption and refraction, the channels through which crepuscular rays stream, mist in the high needles, the way leaves can be like windows, revealing and concealing all at once, even the way trees give themselves up to light as they burn—Kernan's photographs are about the infinity of ways trees and light can intersect. Look at sky (like an explosion of light) through the crown of a bamboo grove; look at the play of shadow along a lane of poplars.

We move through this book, sure, as we might move through a forest, but it moves through us too.

As a species we tend to think of ourselves as separate. There is the "human world," and there is the "natural world." We anthropomorphize, we organize biology in tiers and kingdoms—the plant kingdom, the animal kingdom—above which we kings stride about casually and detachedly. Plants are "lower" forms of life; they are "resources." So much of science is devoted to isolating the individual from the whole: taxonomy, for example, in its attempts to individuate species, or genetics in its attempts to isolate specific genes. The entire scientific method is an attempt to spotlight small fractions of the truth.

But the trees are right here in front of us, more than ready to show us that our way is merely one way to see the world, and not necessarily (not nearly!) the best way. A forest is always so much more than the sum of its parts: moss, lichen, bluebirds, centipedes, aspens, and ponderosas—none of them works alone; none of them can be isolated. The truth the trees know is that there is no division between the human and nonhuman. Everything is shared. We are nothing if not participants in the world.

My hope is that you turn the pages of this book and see in these images something of the thousand landscapes around us—to imagine not only what is inside these frames, but outside them as well, and see how we are connected to the trees of this world in more ways than we will ever understand.

Right now, somewhere, trees are falling, groaning beneath the saw, crashing into the undergrowth, pulling the sky down in their branches. But still others are growing: You can feel them opening (each from a single seed!), driving up through the soil, creeping out into space—in their own understanding of time they are moving fast. Everywhere the trees around you are growing, breathing, preparing, once more, against all odds, to bloom.

—ANTHONY DOERR author of *The Shell Collector: Stories*

Even now, with this long work done, I can't remember exactly when I began photographing trees, or why. I know that it had little to do with the trees themselves.

Whatever it is that calls one away to begin something like this is both so powerful and so chimerical that the only real way to get to the bottom of it is to do whatever it tells you. The best articulation of this process I know of, pungent and provocative, comes from the poet Charles Wright, who said, "I write to find out what it is that I have to say." When I read this, I first understood what I'd been doing all along.

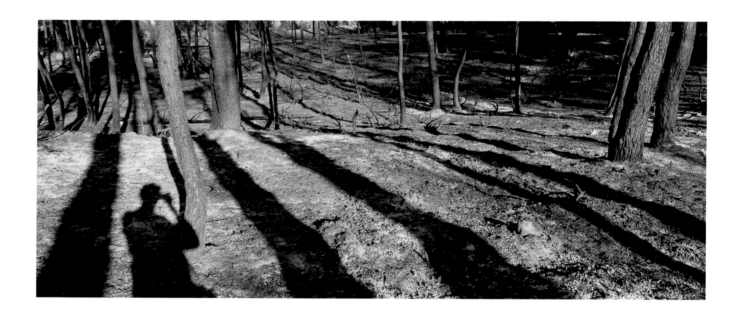

KASSÁNDRA PENINSULA, GREECE

It generally surprises people to find out that most artists working on something—a poem or novel, painting or photograph—don't really plan the thing out and then execute it. Certainly it surprised me. I had always done everything by just jumping in, but I always felt it was somehow wrong (a notion supported by most of my teachers from first grade on). But even for those who do think and plan and make notes, there is still that moment—it can take a minute or months—when the thing at the core of art blooms and something that has been moving beneath the surface of their mind breaks out and floats there just outside it. They see it clearly for the first time, and it's better than anything they had dreamed or planned for. It is the moment that any artist is always hoping for. And one gets to it by doing—writing, painting, clicking—not by planning. The experience is not necessarily comfortable, but the wonderful thing is that if one pays careful attention afterward, the view through one's self is wider, deeper.

When standing in the presence of any great work— Cy Twombly's mural in the Houston Museum of Fine Arts, the big Richard Serras, for example—one sees all of that labor and thought and tempered skill, all of that paint or stone or steel. All of that carries a work, but its heart begins to beat when its maker suddenly realizes that something is emerging that shatters the plan and exceeds it. And the best response is to continue without pausing.

Ironically, the phenomenon mixes epiphany with that moment in a Roadrunner cartoon when Coyote runs off the edge of a cliff and out onto the air without falling. The trick if you're Coyote is to deliberately not look at the fact that you're running on air. The trick if you're the artist is to keep that startled energy going without stopping to think "How am I doing this?"

Because when real creativity begins, it can easily feel as though things are going badly wrong. Yet that is just the time to really persist. I had a tai chi teacher who called this "investing in loss." He had been telling me to balance on one leg, sink lower and lower, and relax my muscles completely while doing it, but I just kept falling over. He was obviously wrong, because obviously squatting lower means to exert more muscle power, not less. When I complained about his teaching, he pointed out that while my falls were evidence that I had stopped relying on muscular effort, I had yet to put my trust in chi. I would have to let go even more, keep falling if need be, to get to the point of giving up what I knew in order to get to what I didn't know. I would have to invest in loss, he said, and if I did, chi would support me. I persisted, and it worked, even though I still didn't think I believed in chi.

When one finally gets to this point of trusting, invoking and using the inexplicable, there follows a heightened feeling of aliveness and connection to everything around one. It's kind of like a drug—and you want more. (In fact, recent imaging work on the functioning of the brain suggests that this kind of extension and completion might be the occasion for a little squirt of dopamine to the brain . . . which might explain why artists keep working in spite of the slim rewards the world gives them.)

I got hints of how this kind of self-extension worked when I left college and began my working life at a theater. I was in pure, true love, full of passion and adrenaline and the self-importance of the overworked. I had no time to think, and that probably was the part that appealed to me most. I simply surrendered completely to the doing. I promised myself I'd do the thinking later.

Then, one night before a photo call, I watched the theater's photographer lay out his gear. The cameras fascinated me—black machines so capable and precise. I followed my fascination without thinking, and I had a camera inside of a week. On my days off I began to take pictures. I loved going off on my own, needing nothing in the way of actors, script, or audience. I could drift around and look, wait to see what happened as the light changed, wait for something to shift and reveal what was right there before my eyes all along. And I didn't care if the

pictures came out in any particular way. I just wanted to see what I'd missed, to learn.

On one of those days I took my first picture that was even a little interesting. I had been wandering through an old abandoned house and happened on to an upstairs room with a tattered curtain billowing over a glowing window. The room wasn't that interesting. But the picture I took was. It was lonelier than the room had been, spookier. There was something in the image that I had completely failed to see when I took it. At first the room had looked like a group of physical objects, but really it was an arrangement of elements that made a certain harmony, a sense of light, a resonance. It was alive, and I saw it.

Taking that photograph of the window was like stepping into a boat for no reason other than it was there, and then noticing that the boat was moving. And instead of yelling "Help" or jumping out, I said to myself, "Where is this going?" I am still finding out.

I've never learned to make this kind of alchemy happen at will, but I have learned to prime it with certain behaviors—going to unfamiliar places,

running around madly, wearing myself out, taking lots and lots of pictures. In time I realized that it wasn't what I was seeing that precipitated the alchemy but the looking itself—the awareness, the attention.

I've never come up with a better way to do creative work, and that's pretty much how I approached this book. It was as though I was walking through forests and across mountainsides and into jungles looking for an invisible matrix that I knew must be there somewhere, one that could be seen only through some tiny ring floating in the air. If I could find the ring and put my eye to it at just the right moment, something in me would shift and the order of the world, or at least some part of it, would become clear. Such rings were rare, but they were out there.

The experience was not particularly serene. Most often it was kinetic, a little frantic, exhausting, but always compelling.

I knew I had found one of these rings whenever I saw that the shifting and fragmentary twigs, trunks, rocks, and clods of earth among which I was moving seemed to be composing themselves into something

that was still, clear in its interconnected parts, and informed by a feeling that something was about to happen. In other words, a picture. In that moment in time and space my mind was able to find order— or perhaps make it. In a world that often seemed senseless, making these pictures let me navigate through chaos to meaning, much in the same way as finding that window had. And if it worked to make a picture, it might lead me to a larger understanding in the process.

Now, any physicist will tell you that the atomic particles that make up our world are separated by proportionately huge measures of space, as are other planets and galaxies. The artist will grab that thought and leap to the idea that the space we inhabit extends to the intergalactic, and thus may contain billions of worlds that we might grasp by just thinking, by awareness. The physicist may try to call the artist back and say, "Prove it," but it is

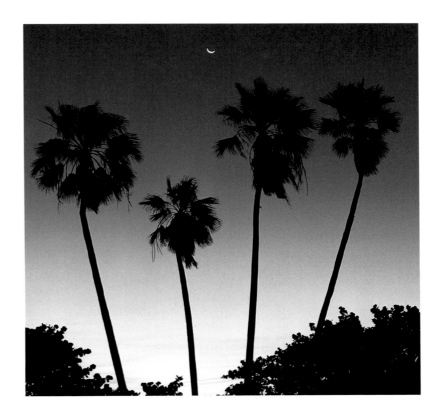

like trying to catch a disobedient dog that has slipped its leash. Besides, artists don't prove.

But the artist is onto something that is true in its way. It is the truth that art gives us, and it arises from being aware. Awareness brings us to consciousness, and consciousness changes us. This then is the function of art—to change our minds, not our thoughts. It's all the reason one needs to be an artist or to appreciate art.

I'd always suspected that something like this might be so, but of course I couldn't begin to prove it. So when I found someone who had, I was thrilled. The

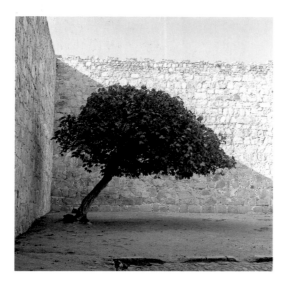

man was Antonio Damasio, head of neurology at the University of Iowa and a pioneer in brain imaging. In his book *The Feeling of What Happens*, he describes some of the science behind the phenomenon of consciousness. He talks about the effect that seeing an object has on the brain, as measured by brain imaging. He observed that the neural pathways of the brain reorganize themselves when exposed to a visual stimulus, and that the revised organization remains in place even when the stimulus is removed. This produces a feeling, a narrative that becomes what Damasio described as "the movie in the brain." The outcome is that the seer is changed by the act of seeing.

Damasio is saying that we notice what we have not seen before, and its newness changes us, extends our consciousness. As a result we are different, expanded.

Damasio is not talking about art per se, but I think artists work quite directly with this phenomenon. It is in this state of aliveness that new work is born. (There is a story that as Mondrian was painting over some old canvases he had lying around, a friend

reproached him for covering up perfectly good pictures. "I'm not trying to make pictures," he said. "I'm trying to find things out.")

In my nonscientific way, I think this view of the function of art suggests that existence is a bunch of possibilities, and that part of what shapes and gives it meaning is our gaze, our awareness. In other words, the world we see is of our making!

All this exposition may give the impression that I was thinking about all this while taking the pictures in this book. I wasn't. If making them was an exhilarating and sometimes overwrought experience, it is also true that there were the quiet pleasures of walking through the woods. My world's surface is almost entirely manmade. The ground I walk on is parking lots, lawns, elevator floors, roads, and sidewalks. To walk directly on earth is an exception. So whenever I wasn't beating the bushes trying to startle another picture into the open, I walked: through the redwood forests of California, the pines of northern Greece, the foggy hardwoods of New

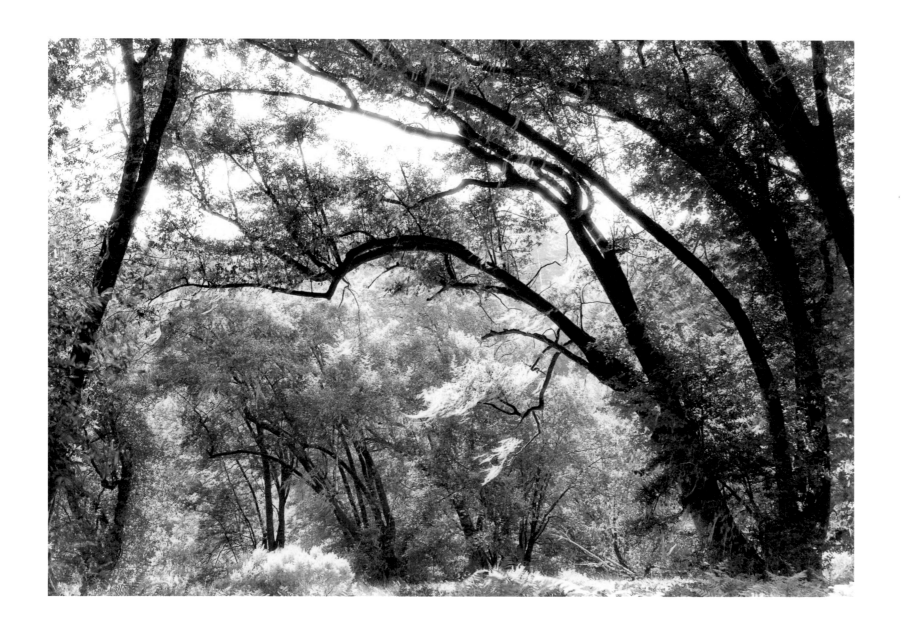

POINT REYES, CALIFORNIA

15

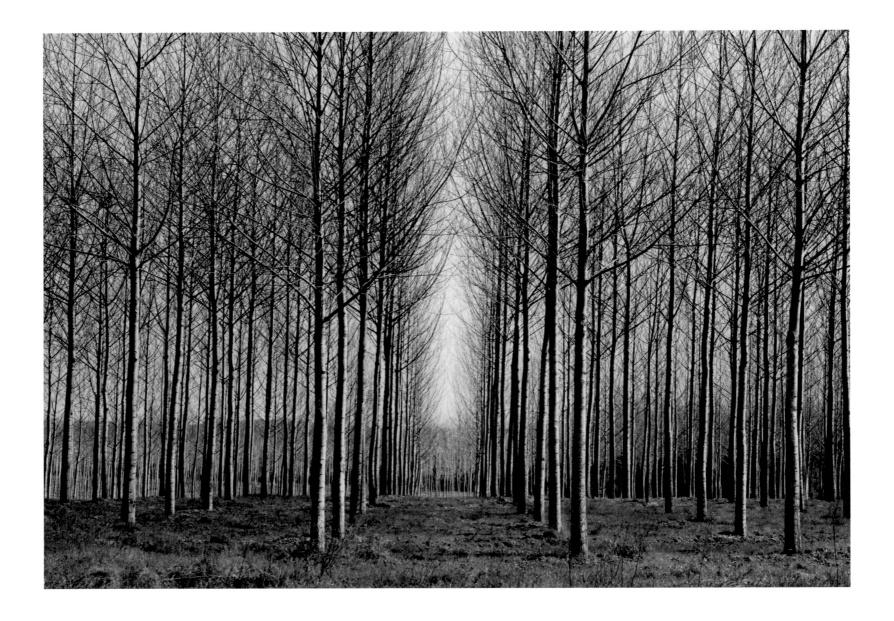

UMBRIA, ITALY

England. Looking up through a bamboo forest at what seemed like explosions of light above literally made me gasp with surprise.

And when I walked out of the woods, I was always more alert to those interesting interstices where humanity had done its work, as opposite as Capability Brown's great landscape garden at Stowe, England, and the clear-cuts on the Olympic Peninsula of Washington.

There was Hatfield Forest near London, preserved as a royal hunting forest since medieval times. I visited the San Joaquin Valley, where commercial agriculture has been taken further than anywhere on earth, lining up every living profitable plant and leaving only a few of the great tousled valley oaks that were native there. And I was seduced again and again by the straight rows of poplars grown for pulp in Italy.

And the olive groves! As a teenager one summer in Spain I fell in love with olive trees. The sage-colored drifts of their leaves against the khaki hills, the dance of trunks in their groves moved me to return

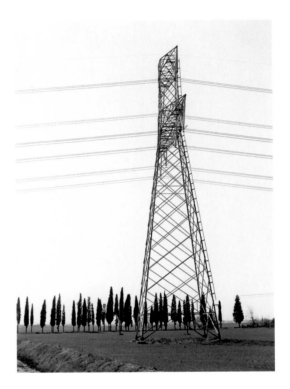

to olive groves, this time in Greece, like a gypsy in a poem, to look quietly among those oldest of working trees for their harmonies.

Clearly, when I said that this project had little to do with trees, I was being disingenuous. I loved doing the walking and the work among them, and I feel a little lost now that I don't have in my pocket a plane ticket to some place where I've heard the forests are full of magic.

Still, in the end, this work was not about trees but about seeing and changing. That's what art—making it and seeing it—does. It's not decorative, it is completely and deeply functional. Art changes the mind.

From the first, I had the sense that in the woods was something waiting for me—a larger, unifying awareness of objects, lives, atmospheres, things that could exist but don't yet. The only way to uncover it was to go about looking for and making these pictures.

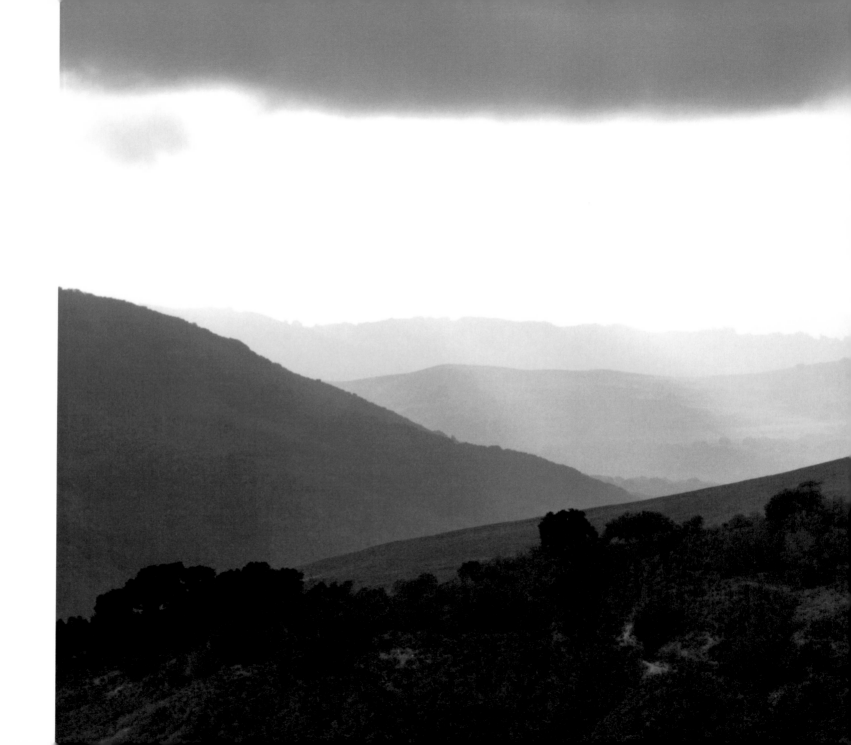

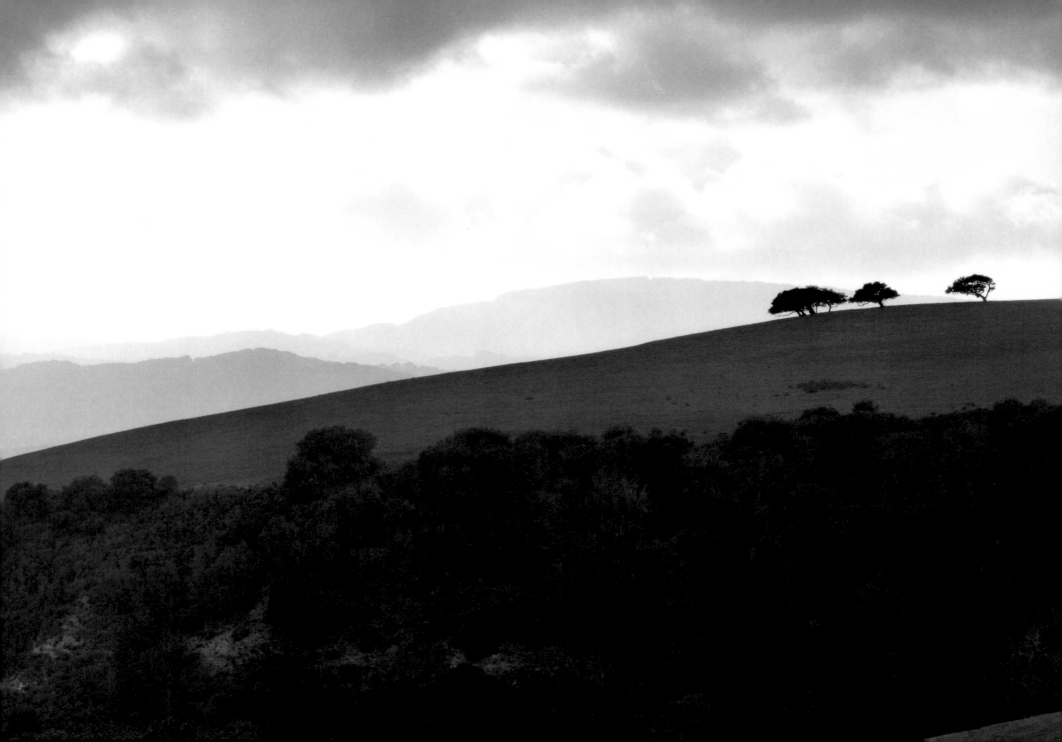

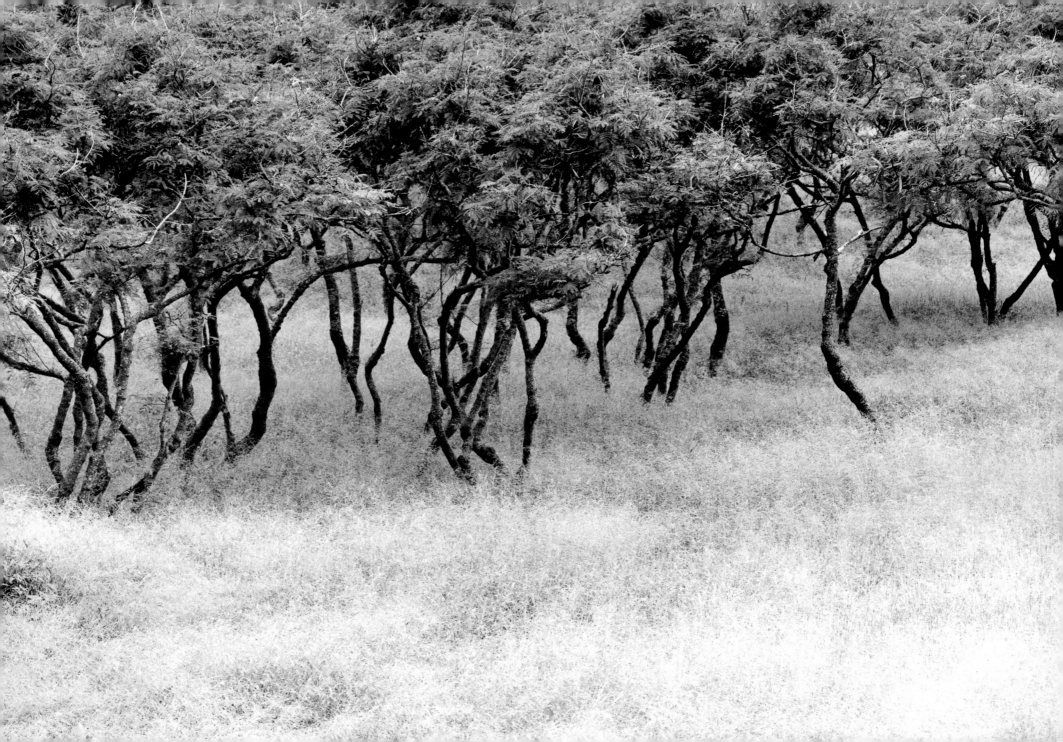

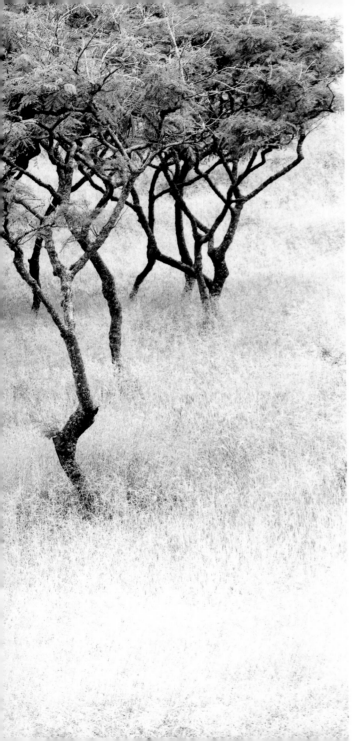

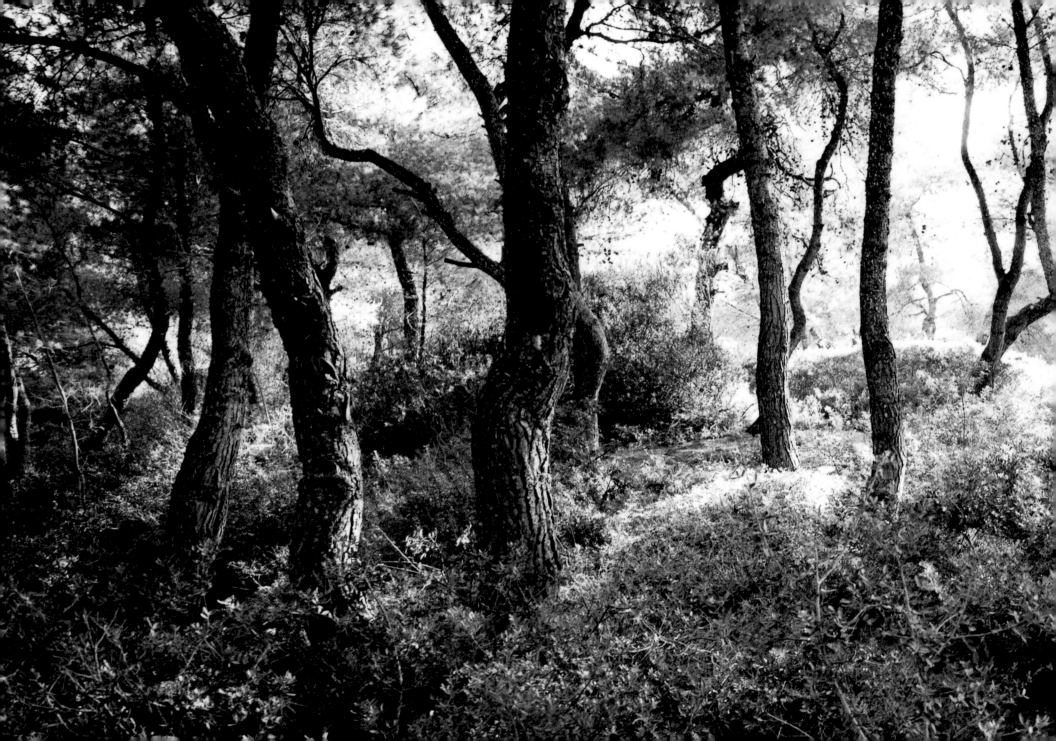

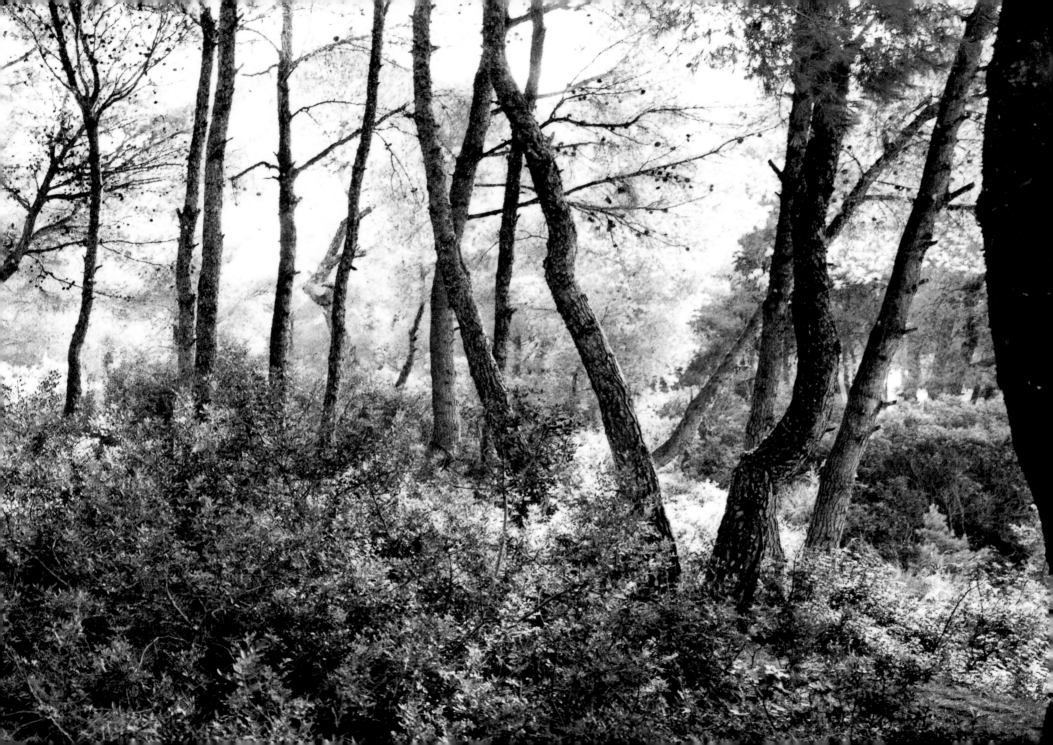

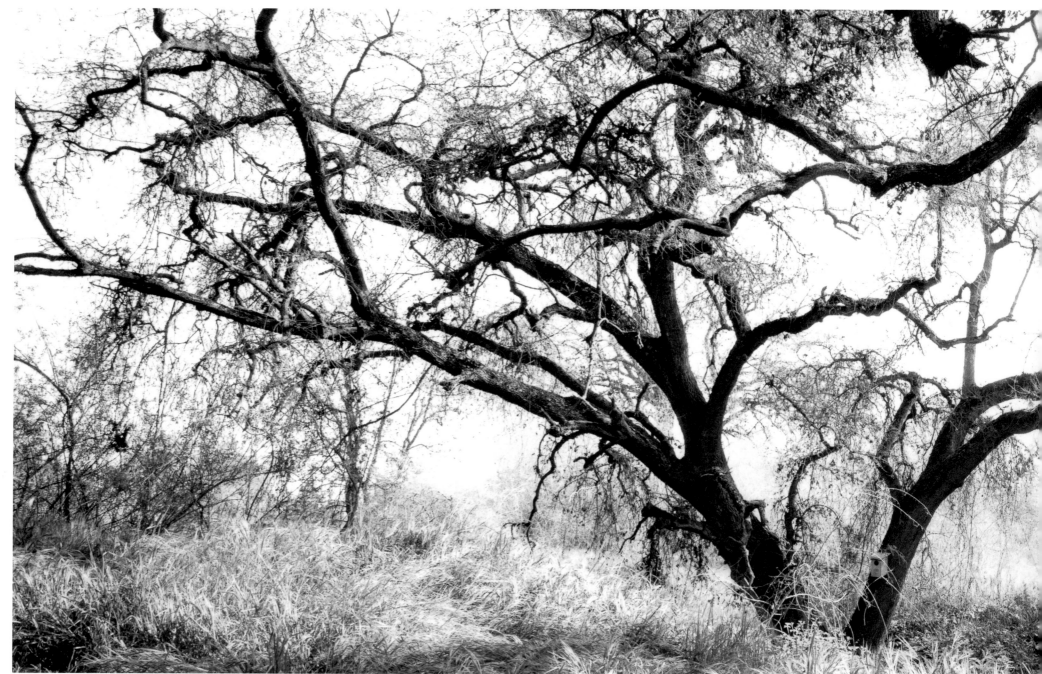

SAN JOAQUIN VALLEY, CALIFORNIA

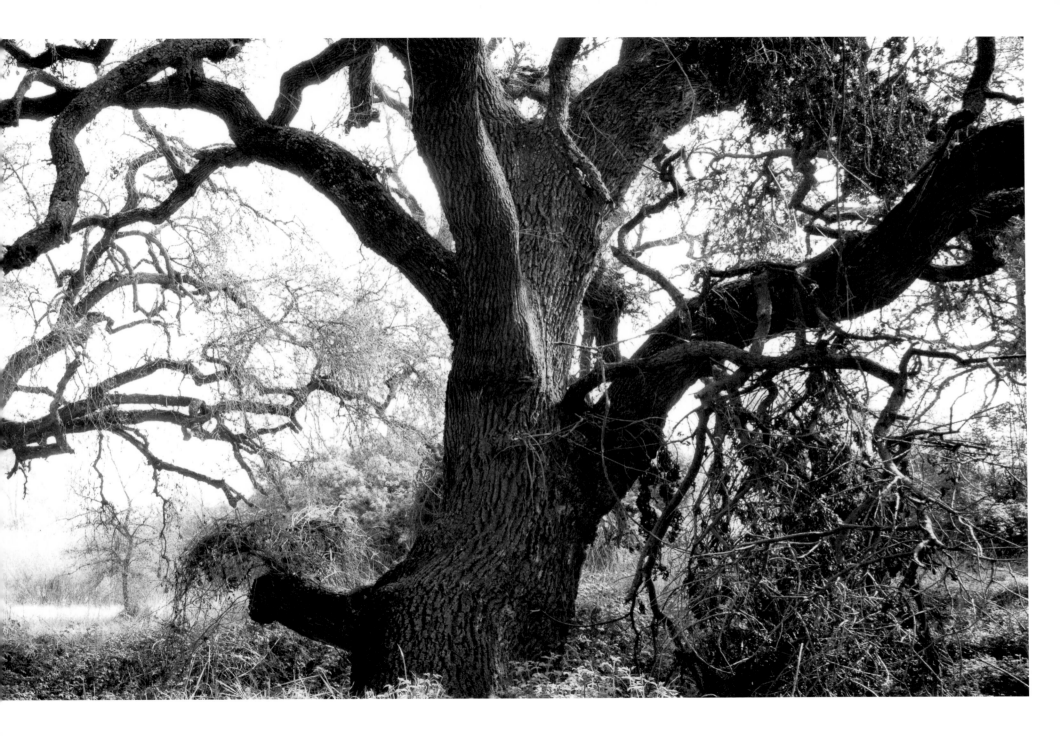

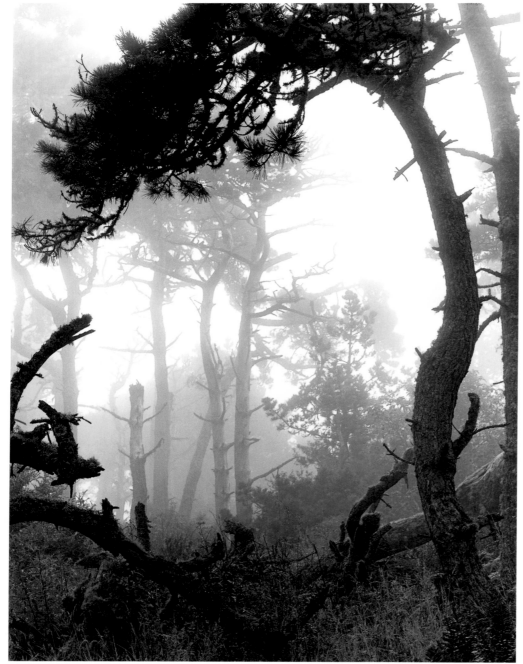

POINT REYES, CALIFORNIA

JOSHUA TREE NATIONAL MONUMENT, CALIFORNIA ▶

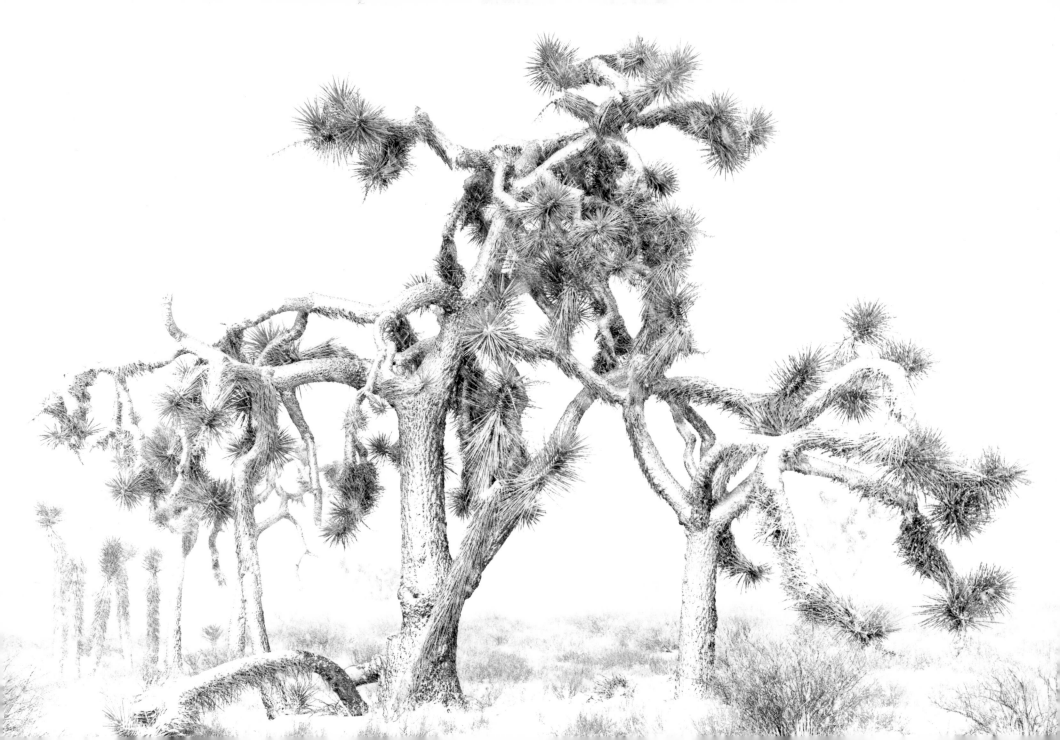

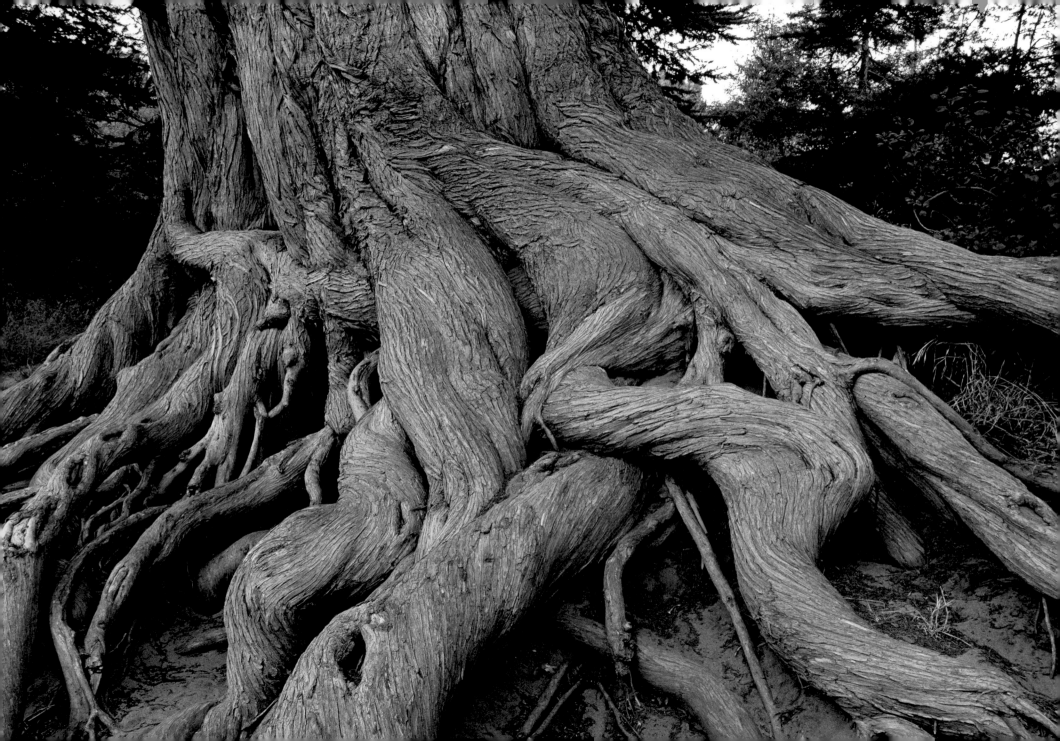

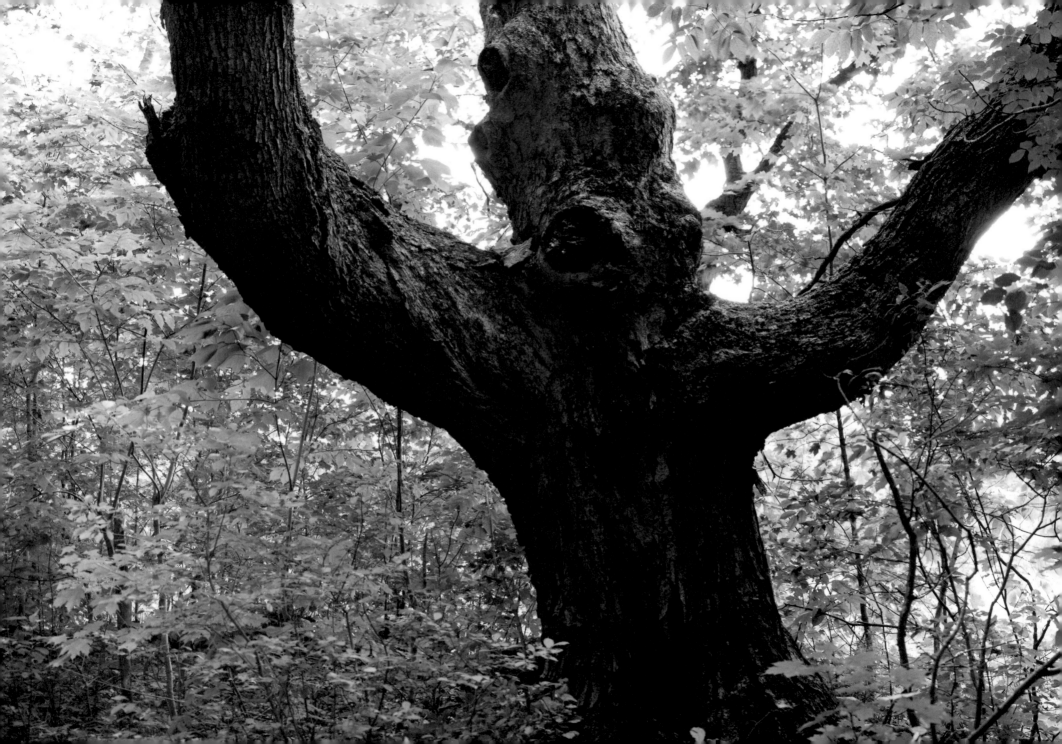

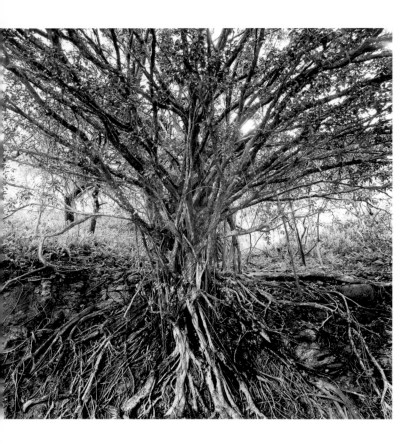

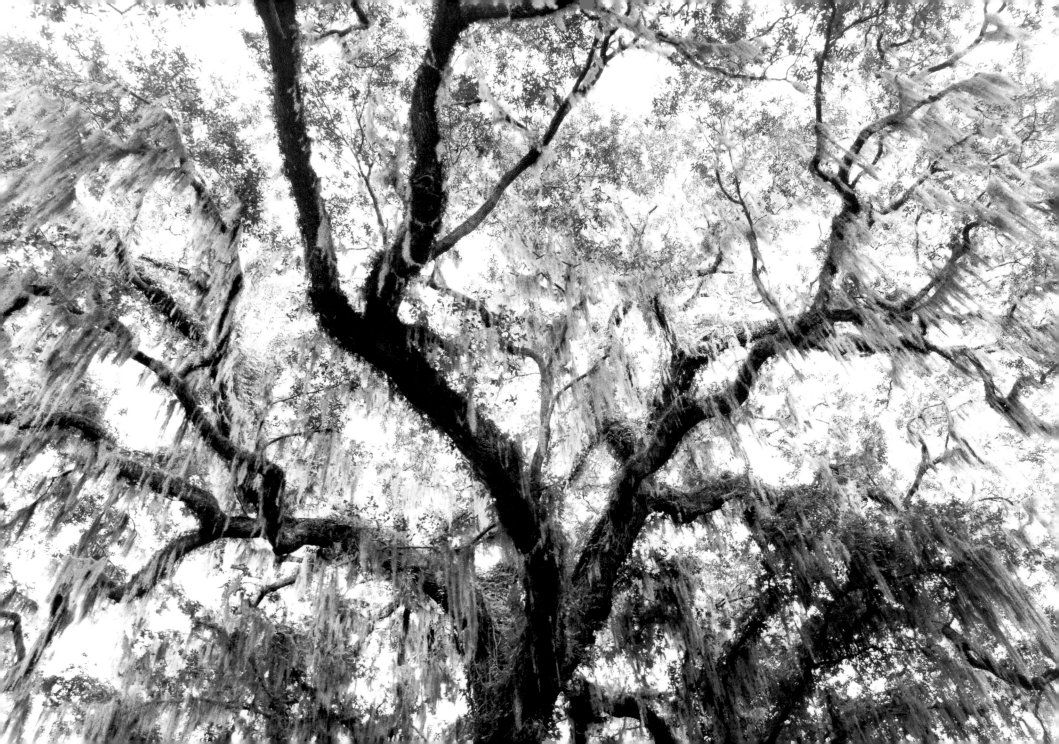

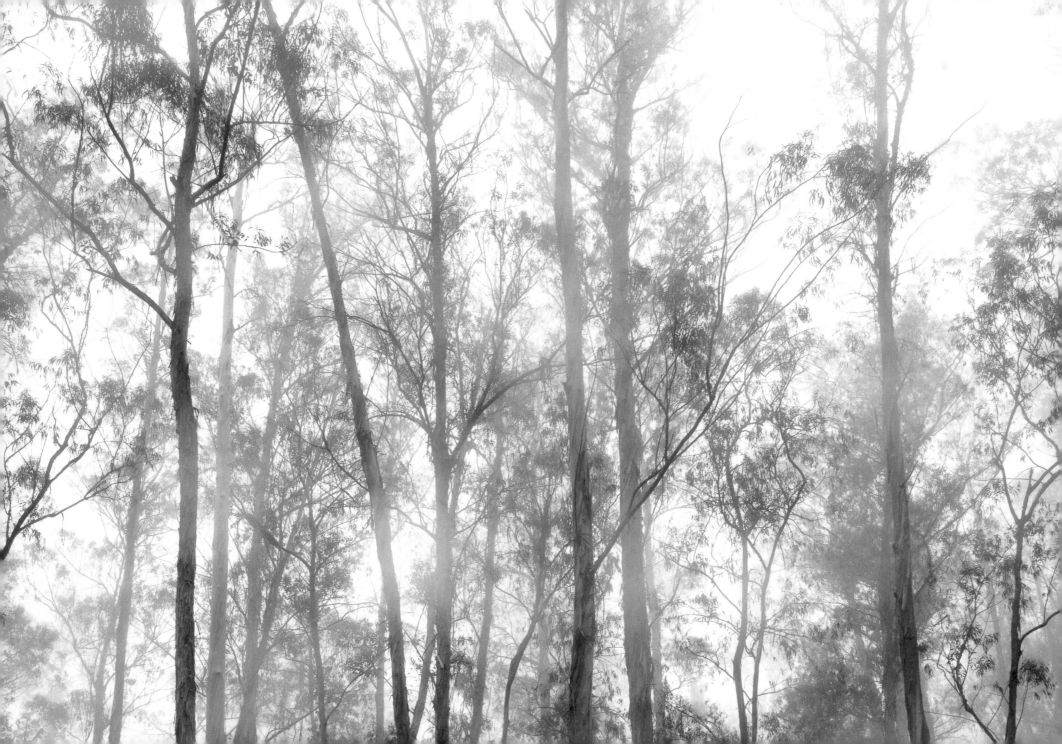

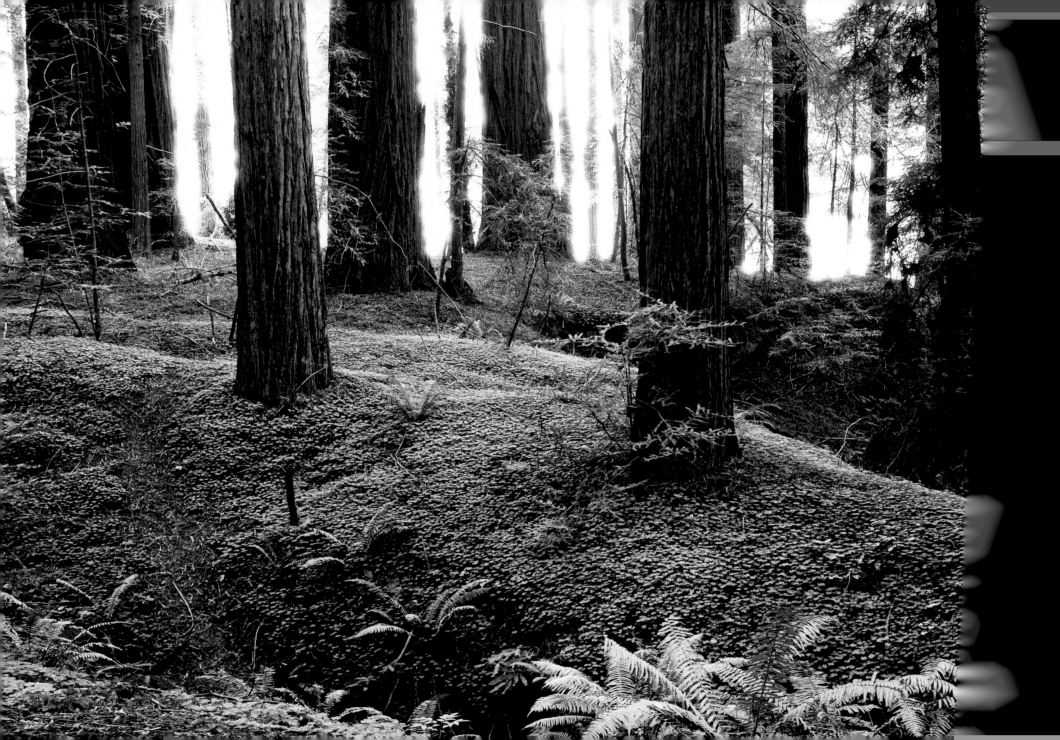

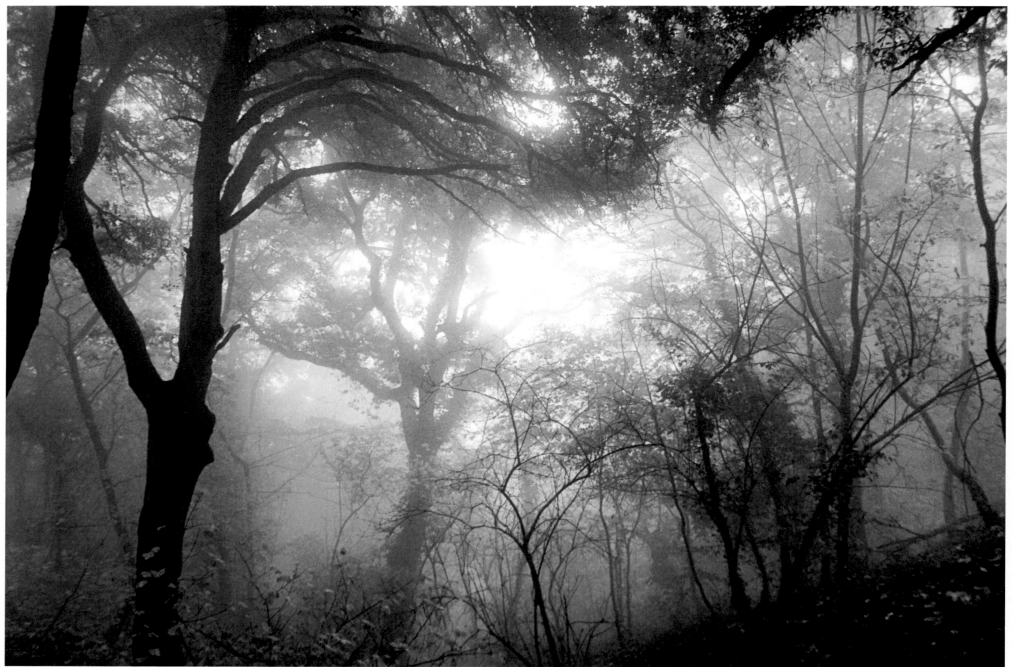

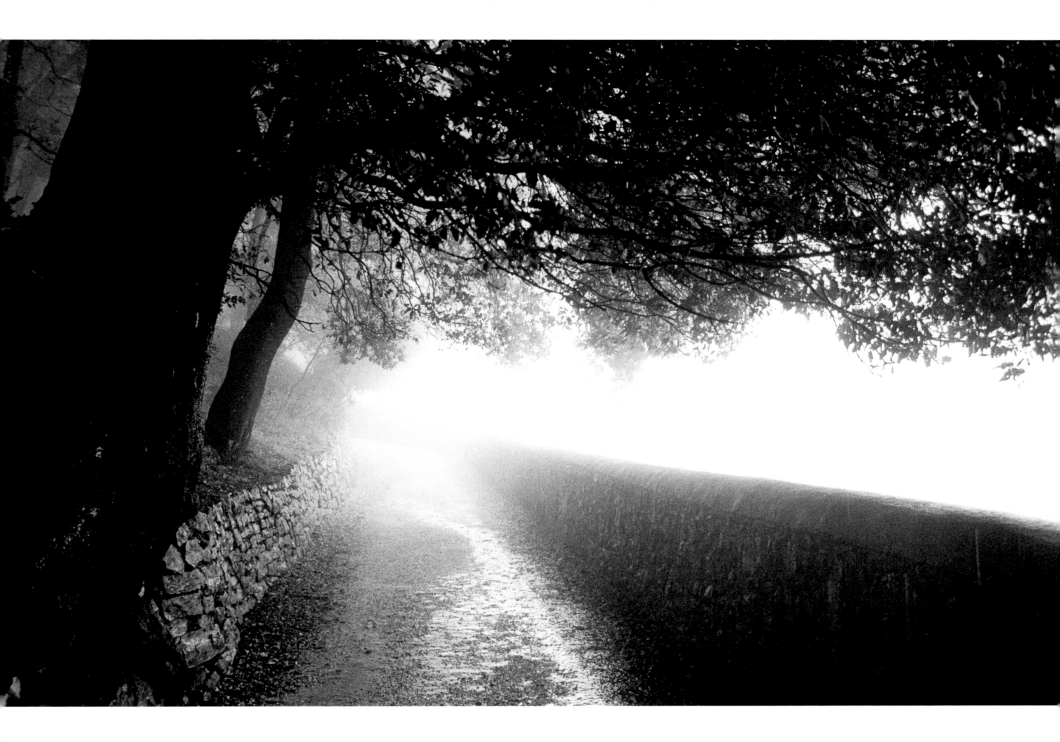

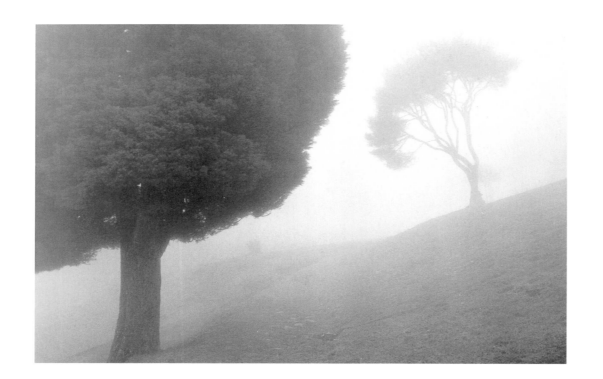

DARJEELING, INDIA

ASSISI, ITALY

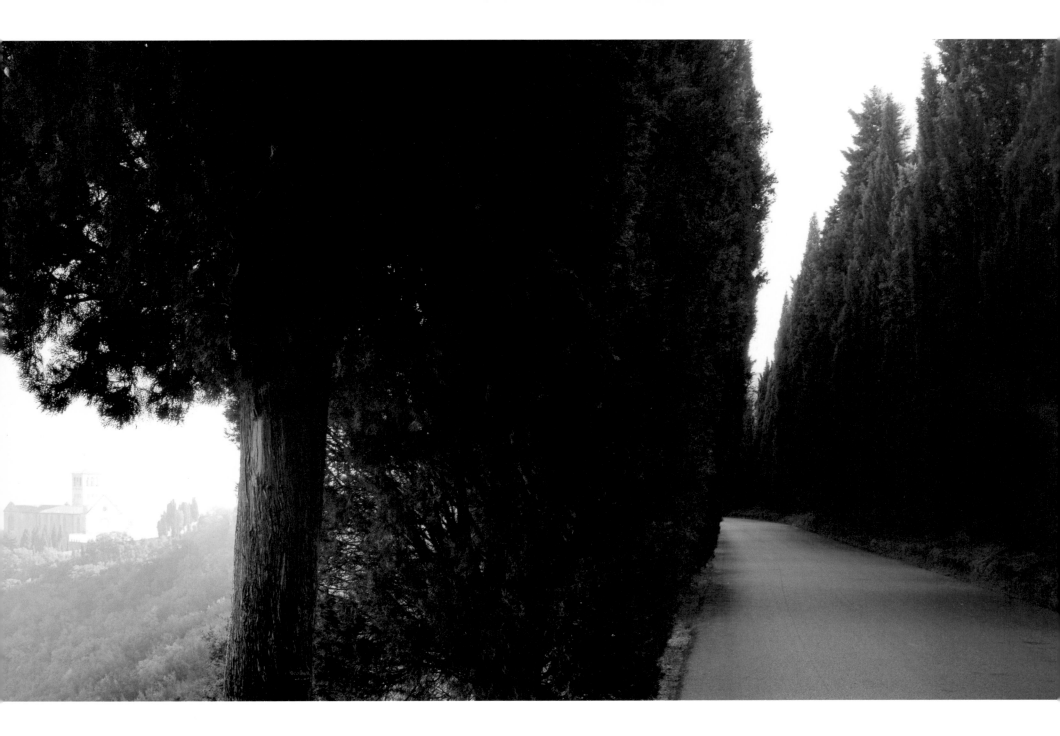

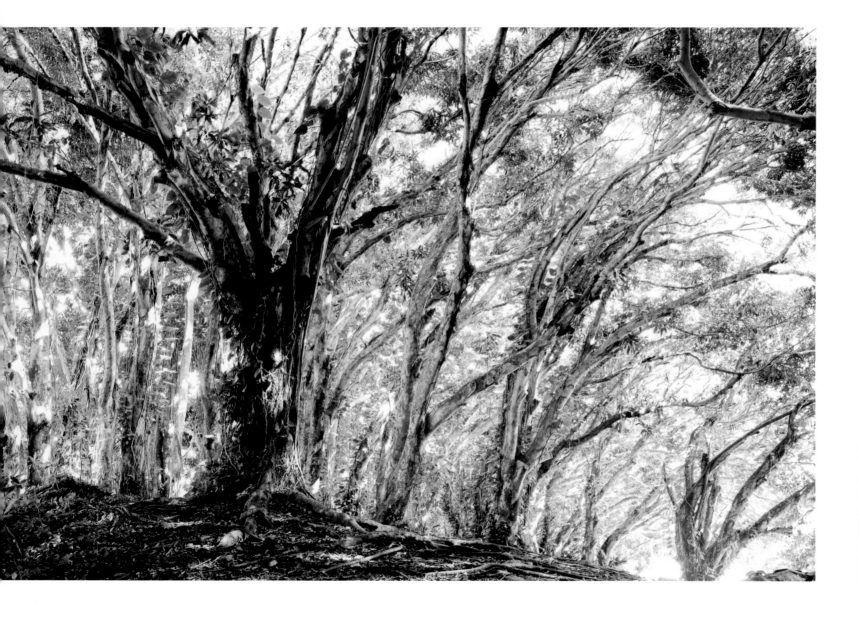

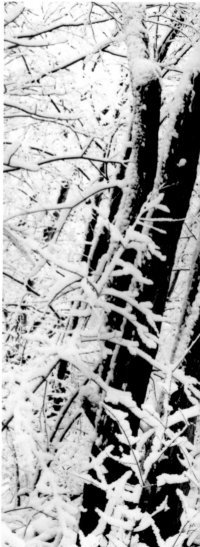

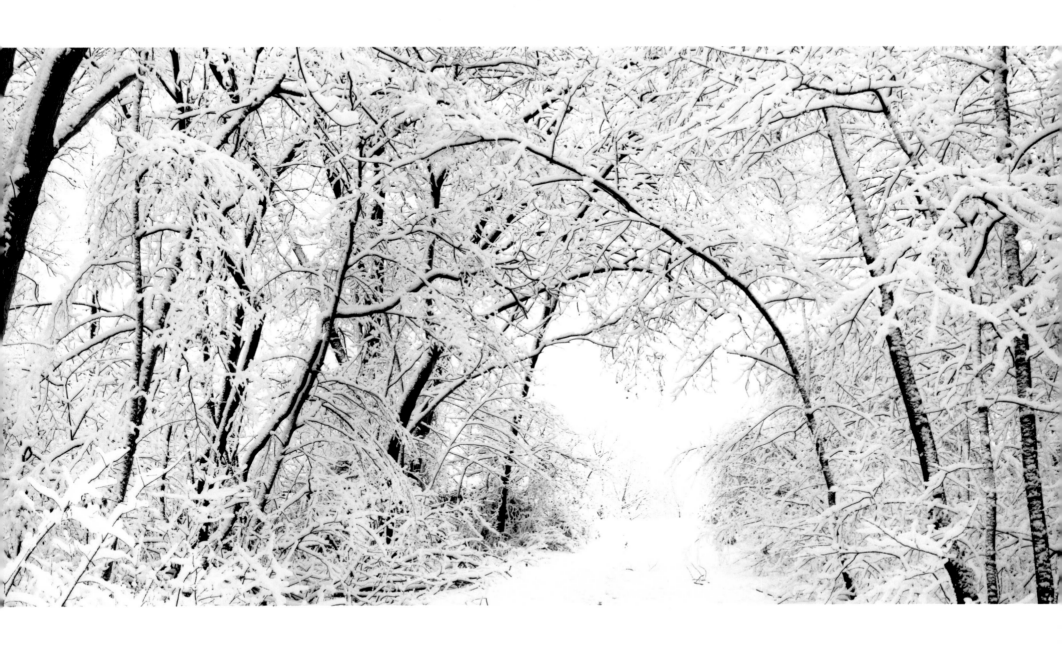

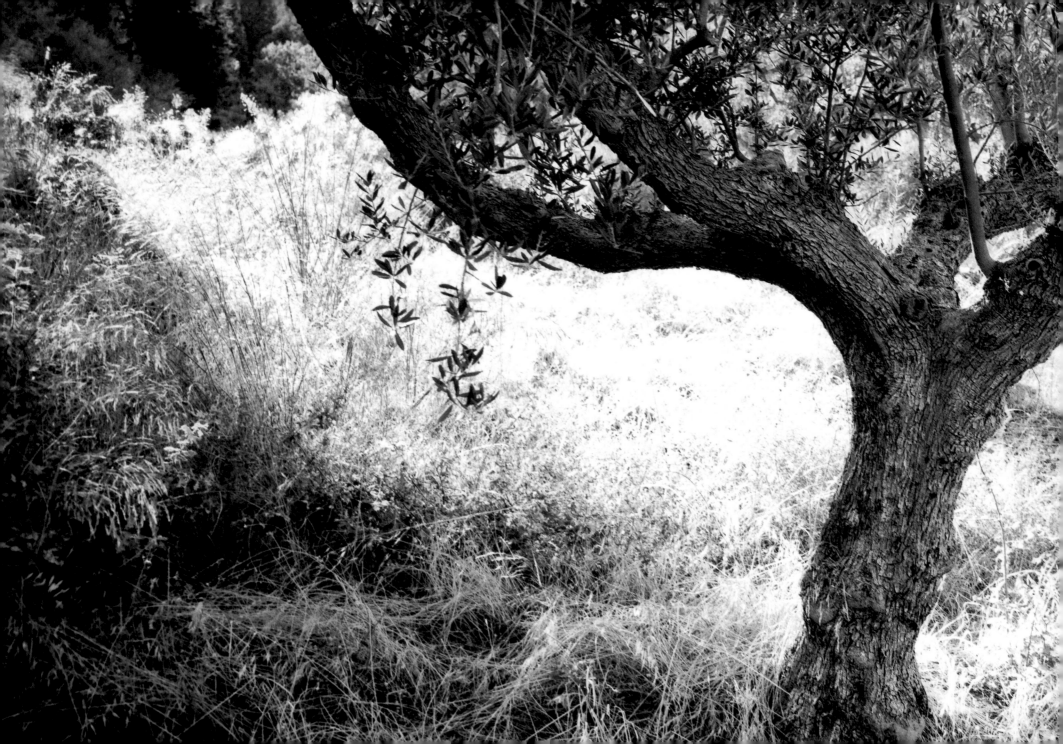

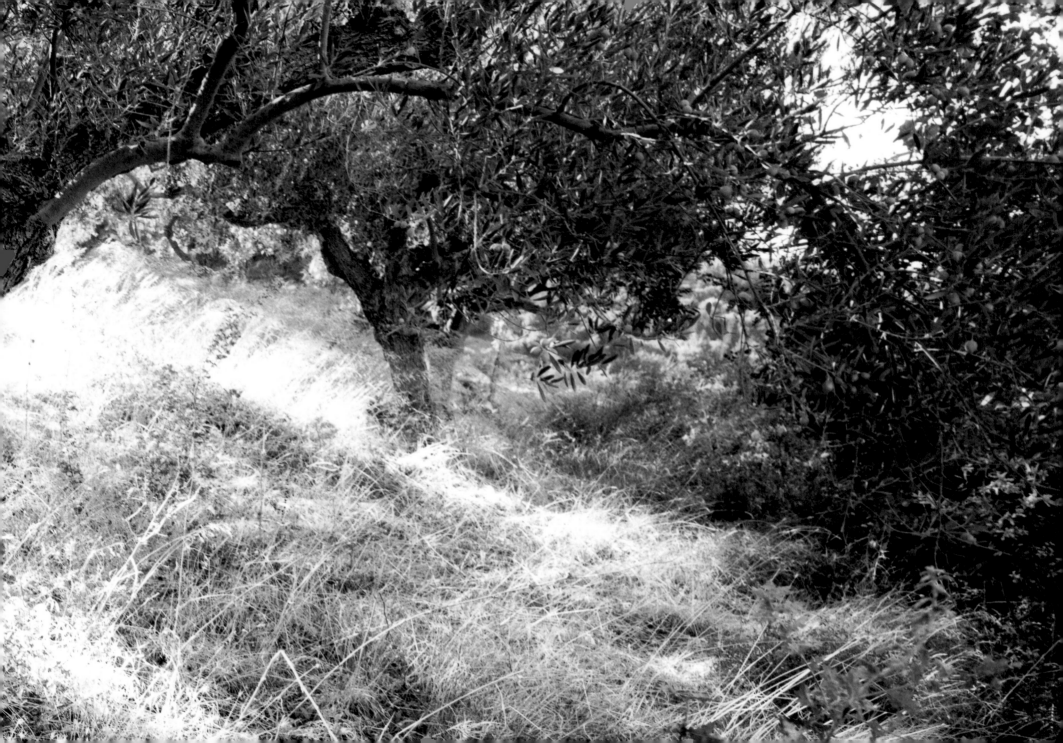

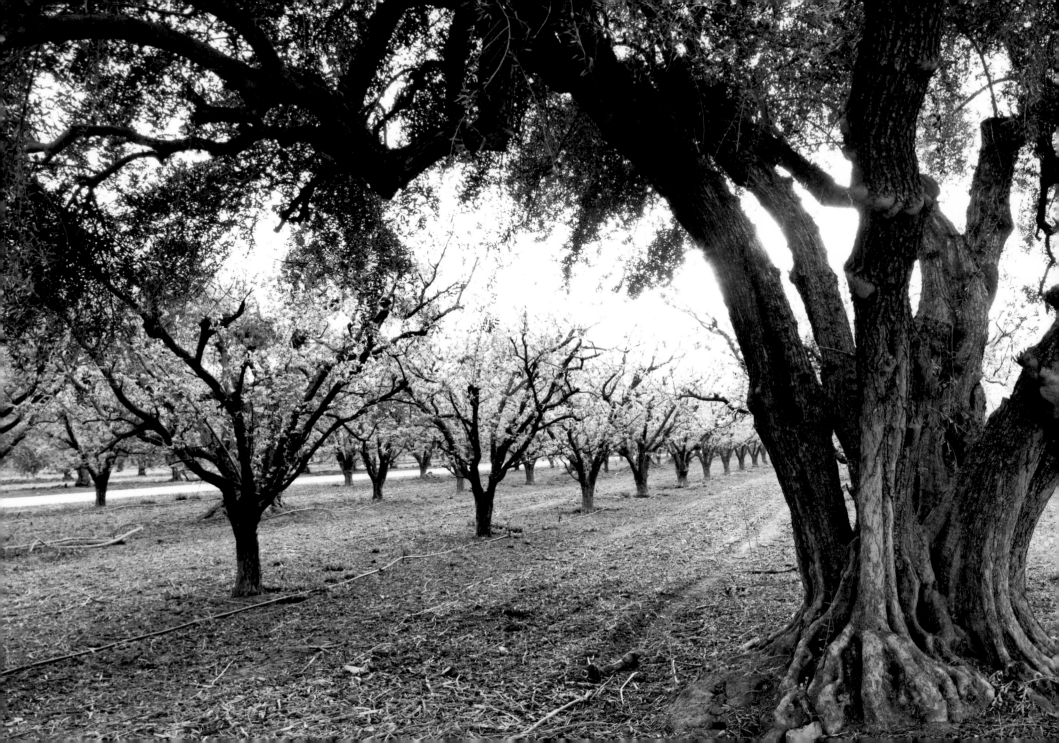

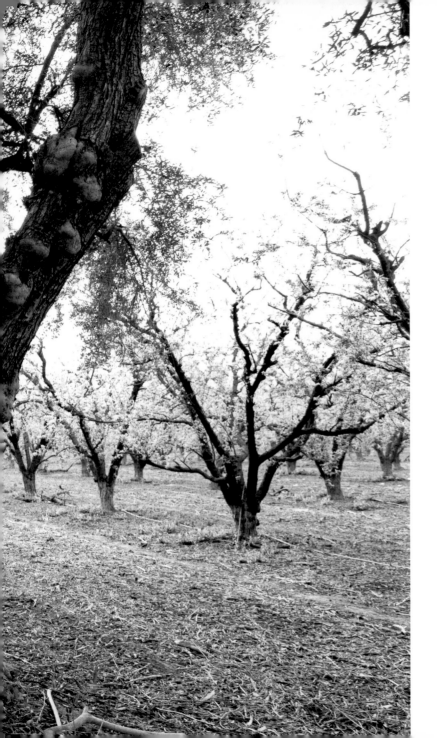

SAN JOAQUIN VALLEY, CALIFORNIA

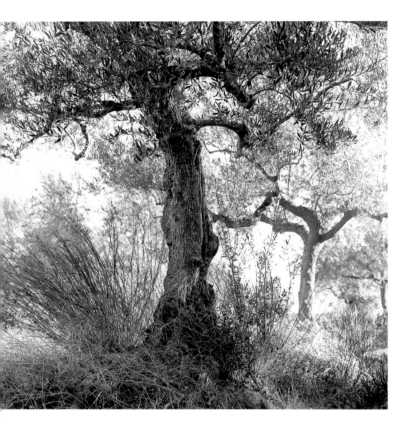

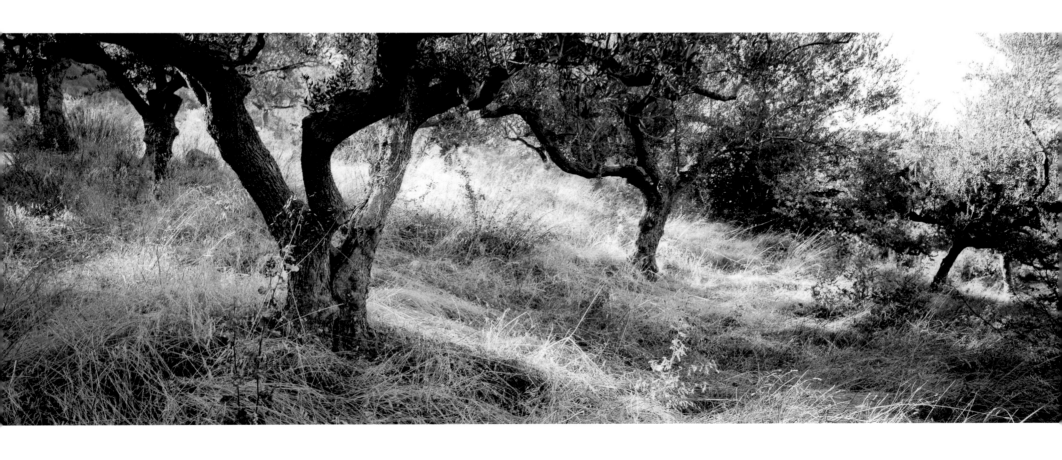

EPIDAURUS, GREECE

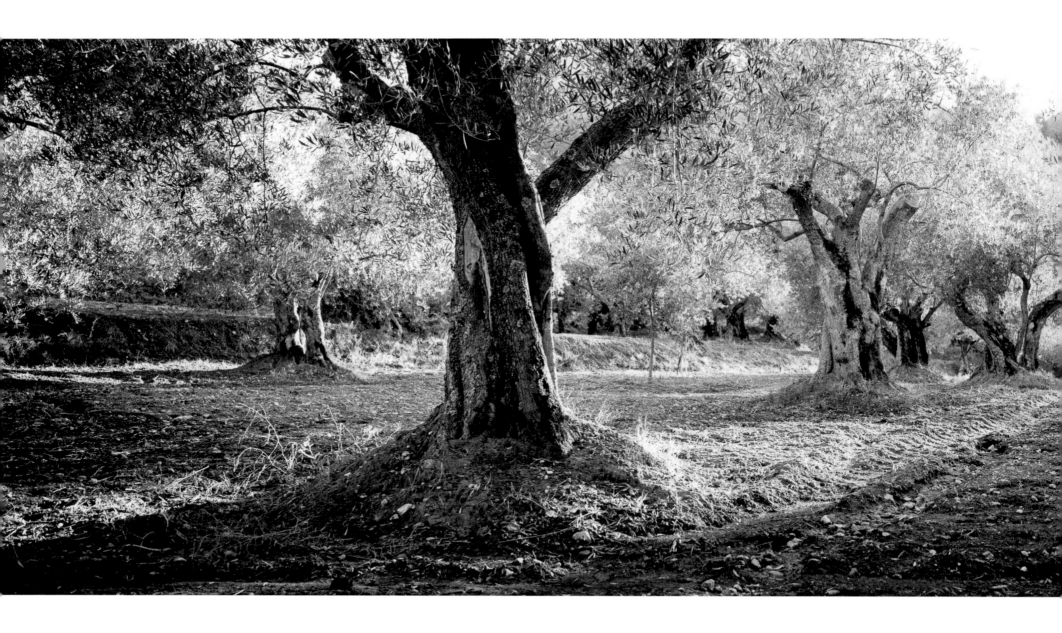

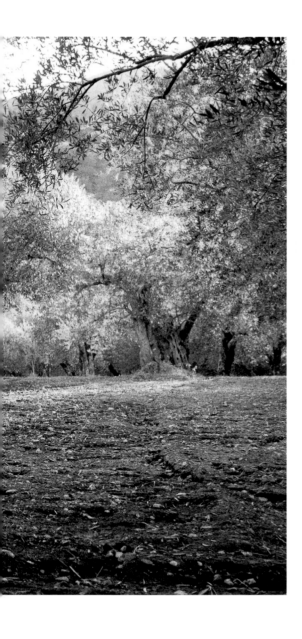

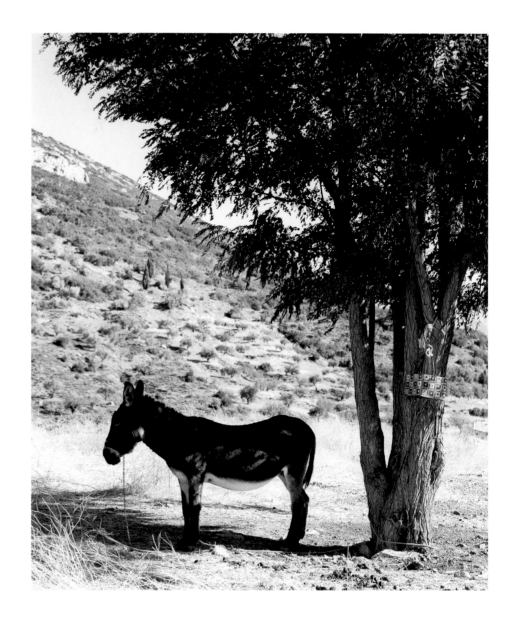

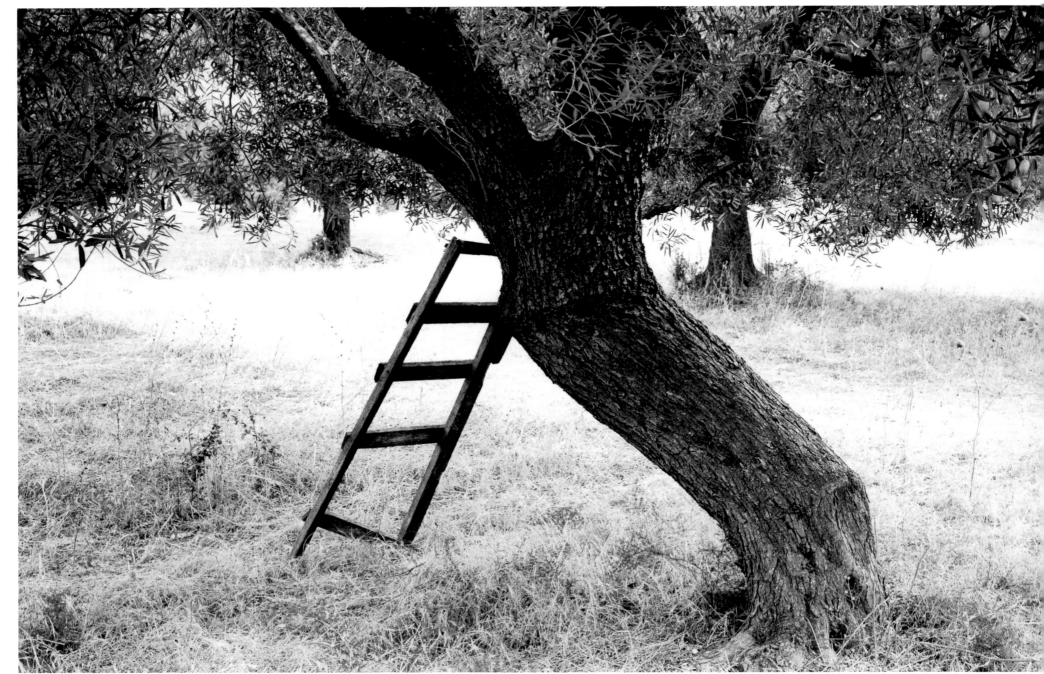

KASSÁNDRA PENINSULA, GREECE

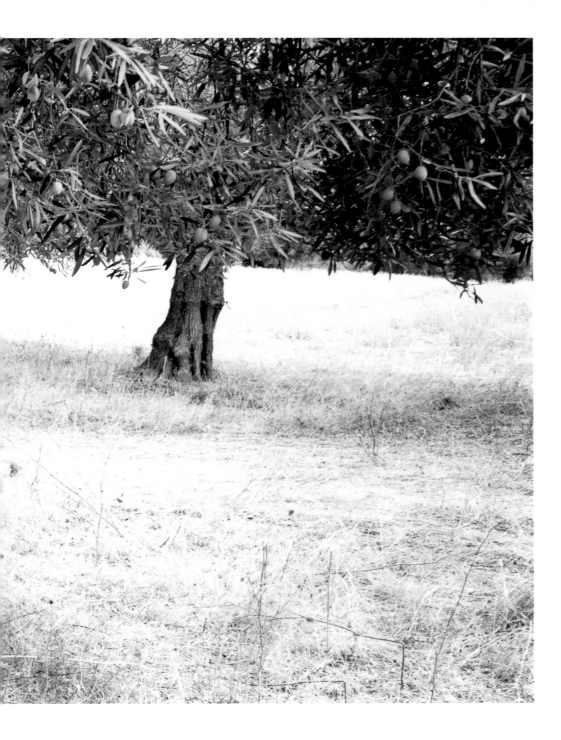

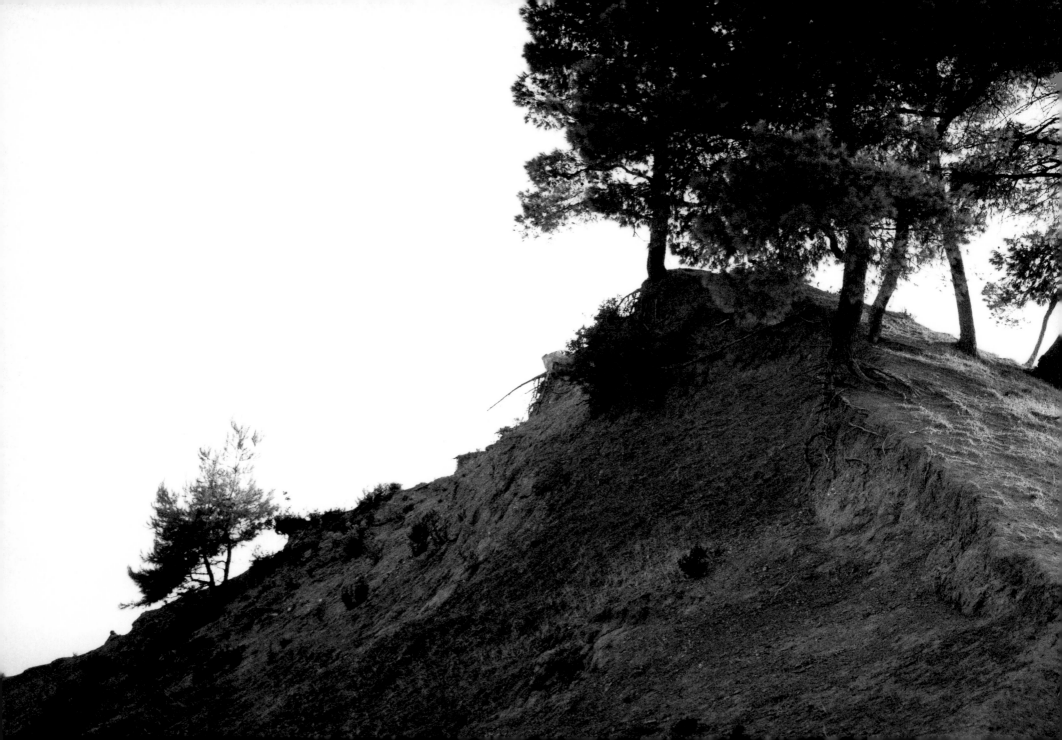

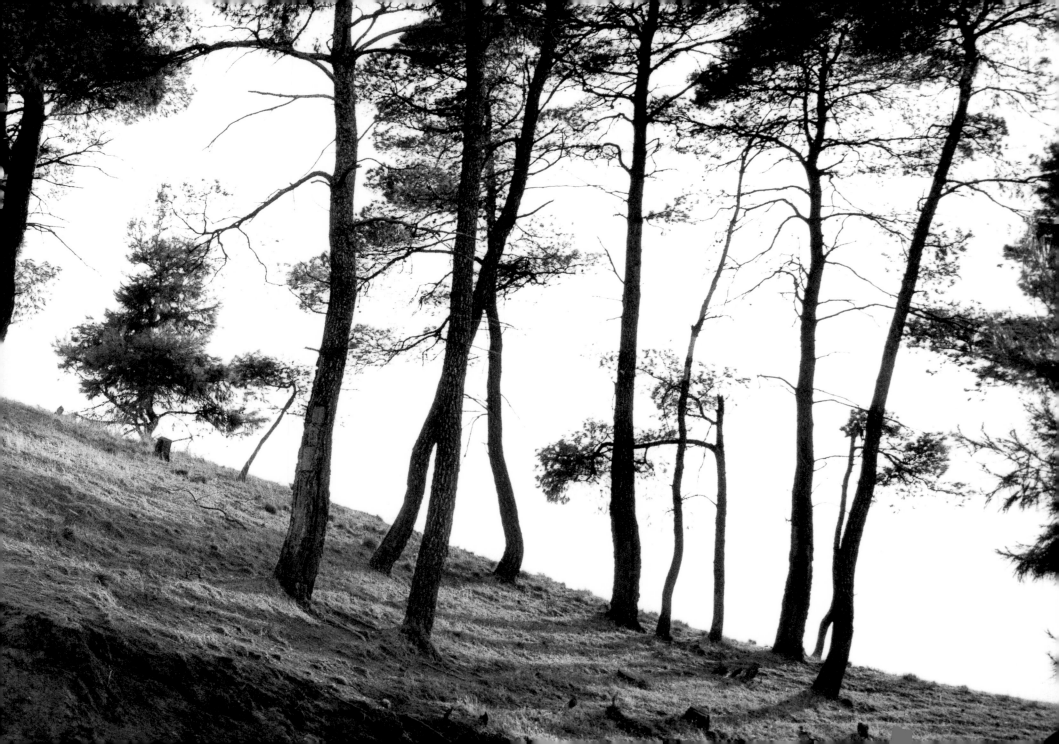

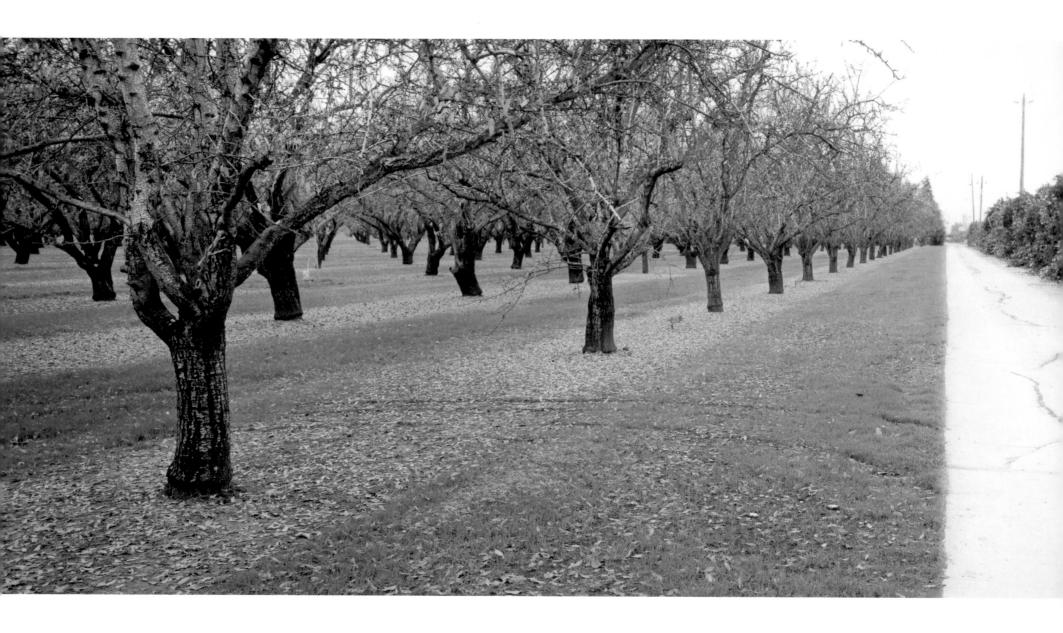

SAN JOAQUIN VALLEY, CALIFORNIA

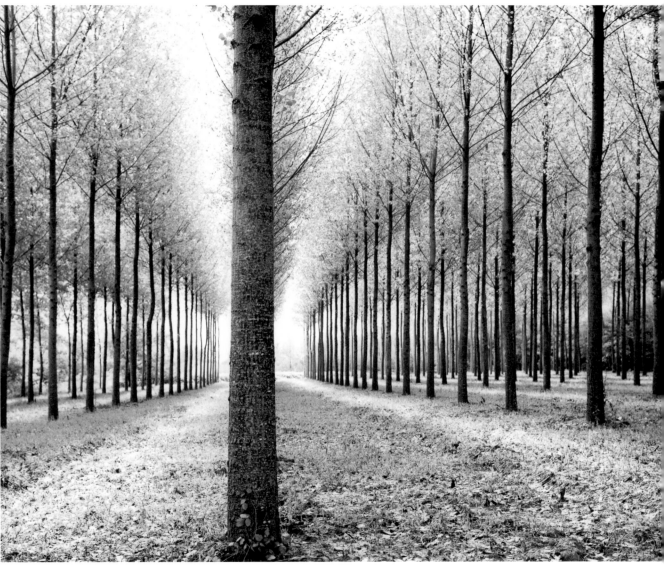

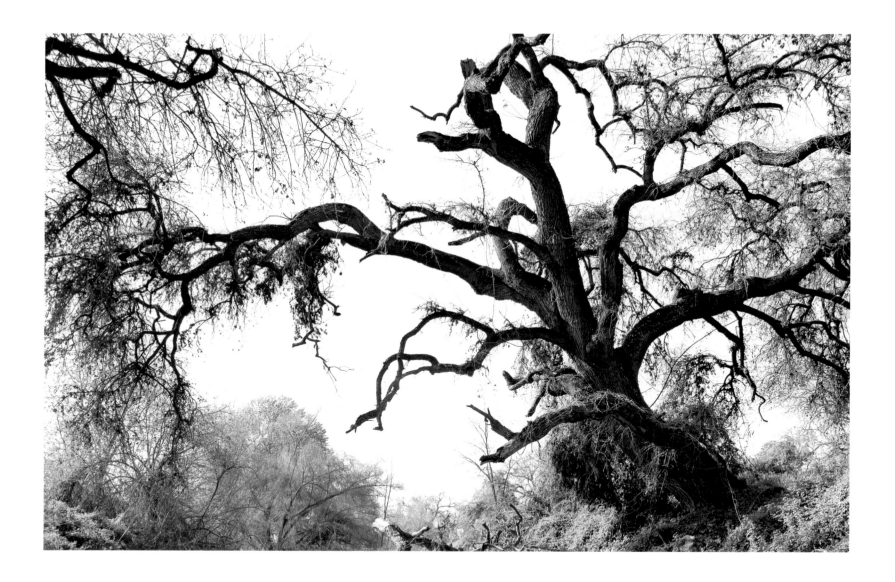

SAN JOAQUIN VALLEY, CALIFORNIA

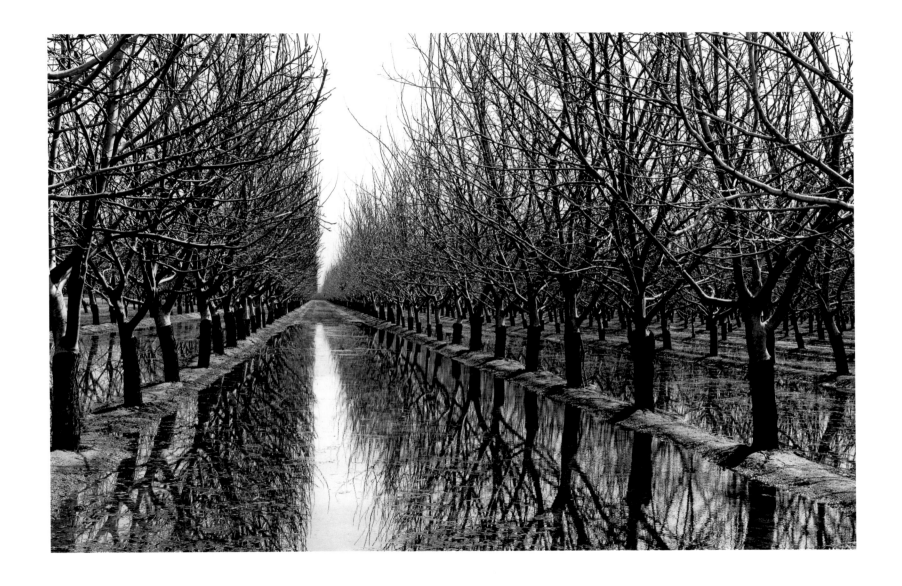

SAN JOAQUIN VALLEY, CALIFORNIA

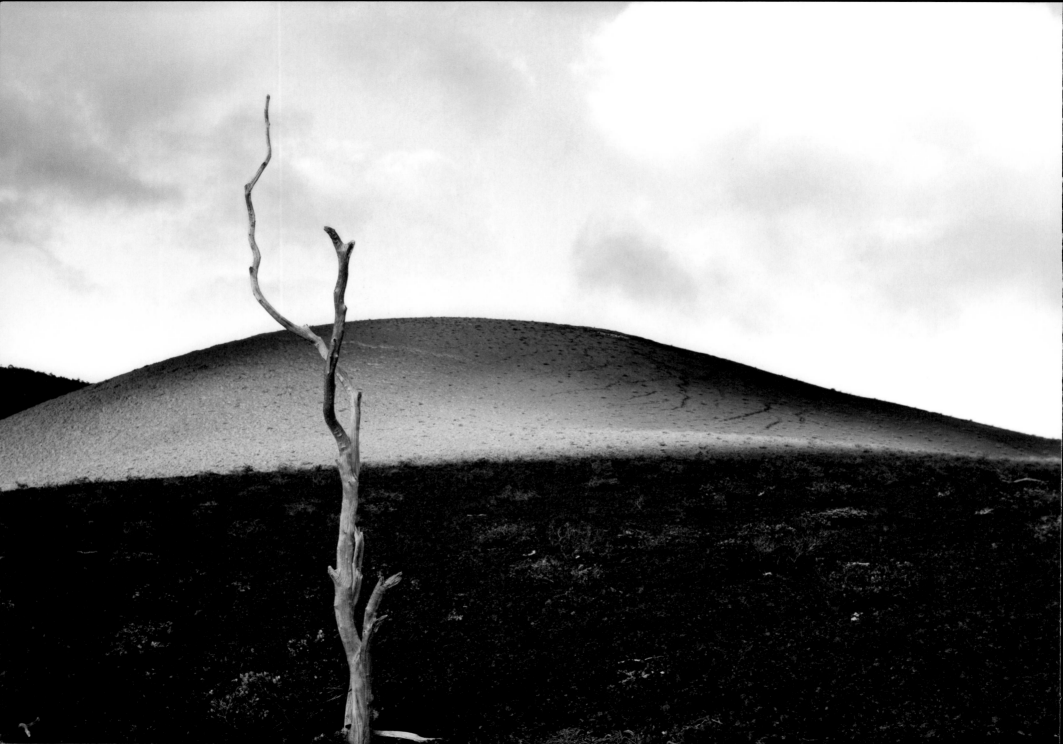

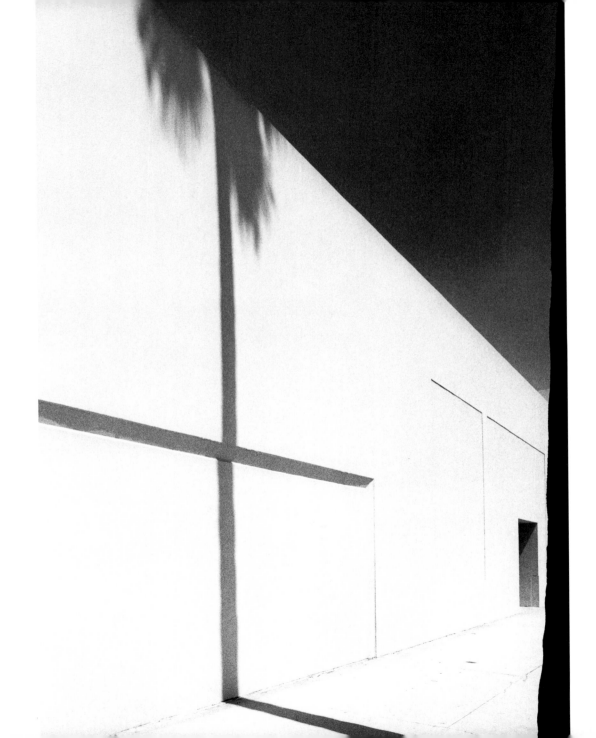

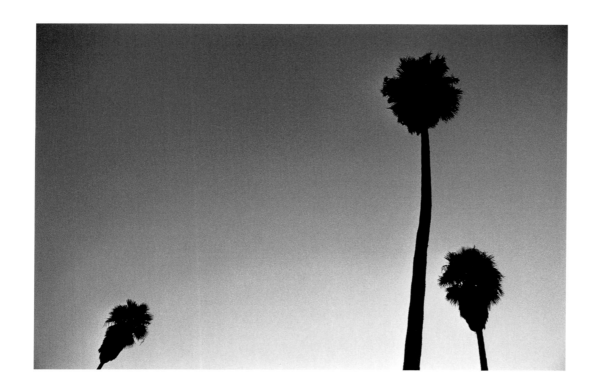

▲ LOS ANGELES, CALIFORNIA ▶

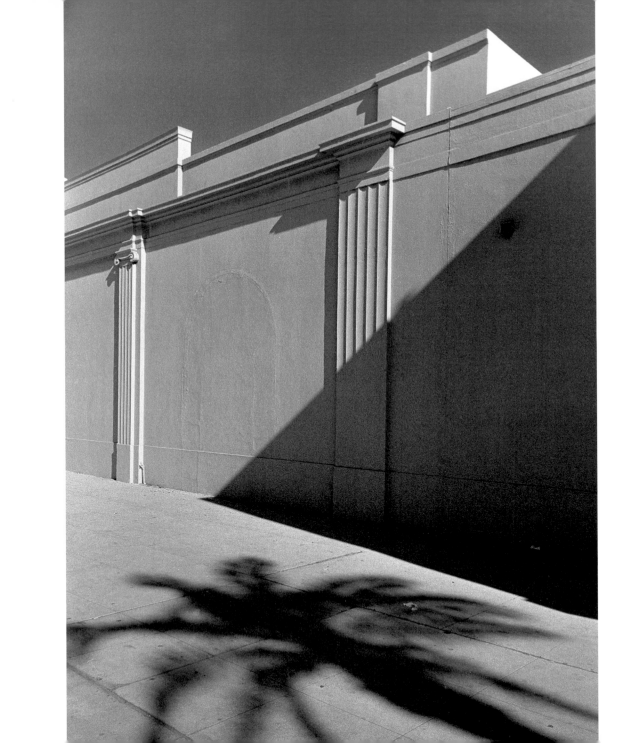

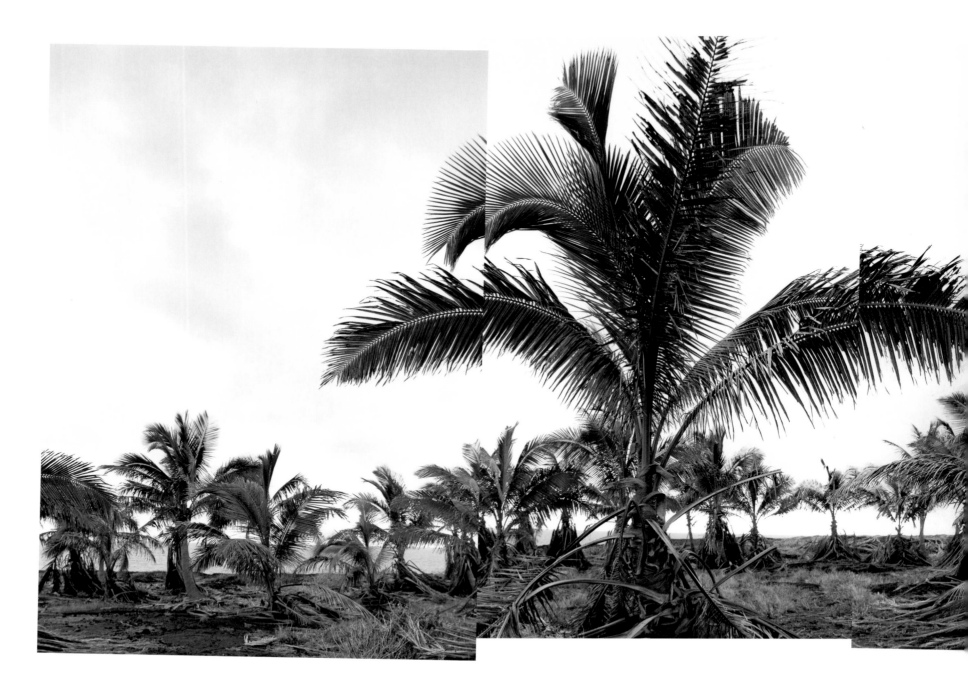

BIG ISLAND, HAWAII

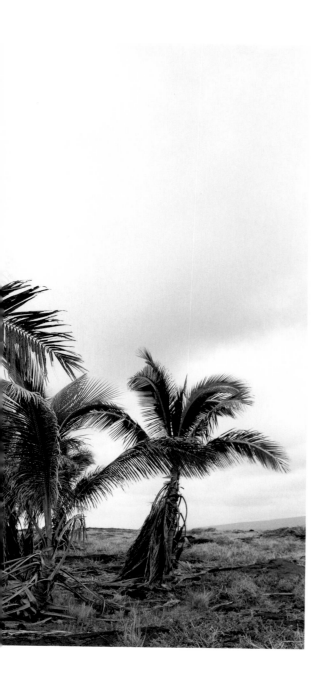

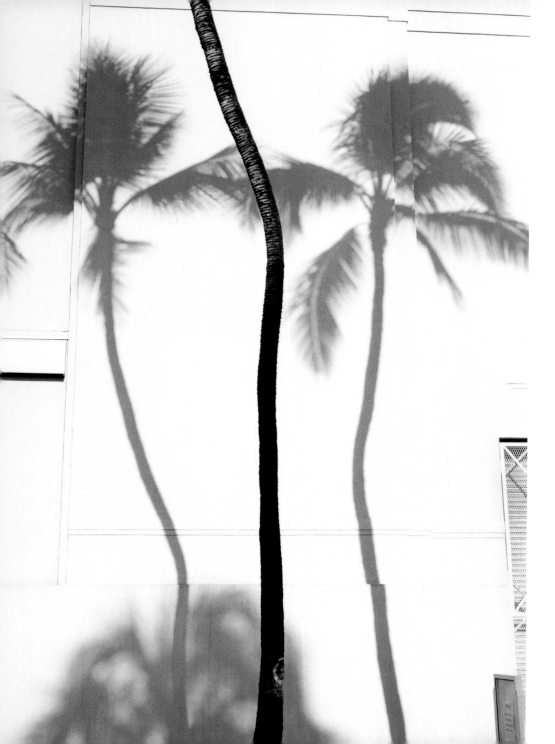

MAUI, HAWAII

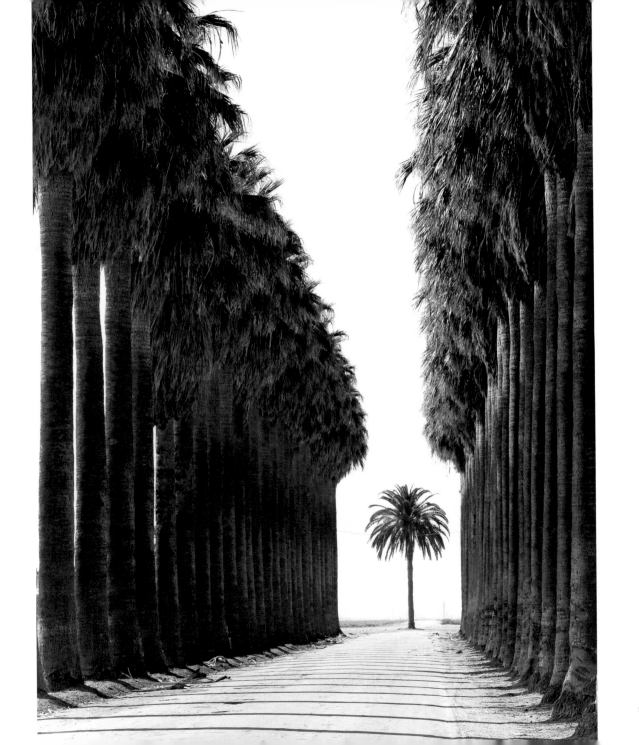

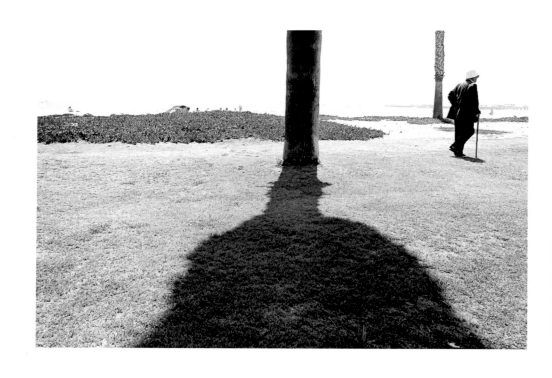

MALIBU, CALIFORNIA

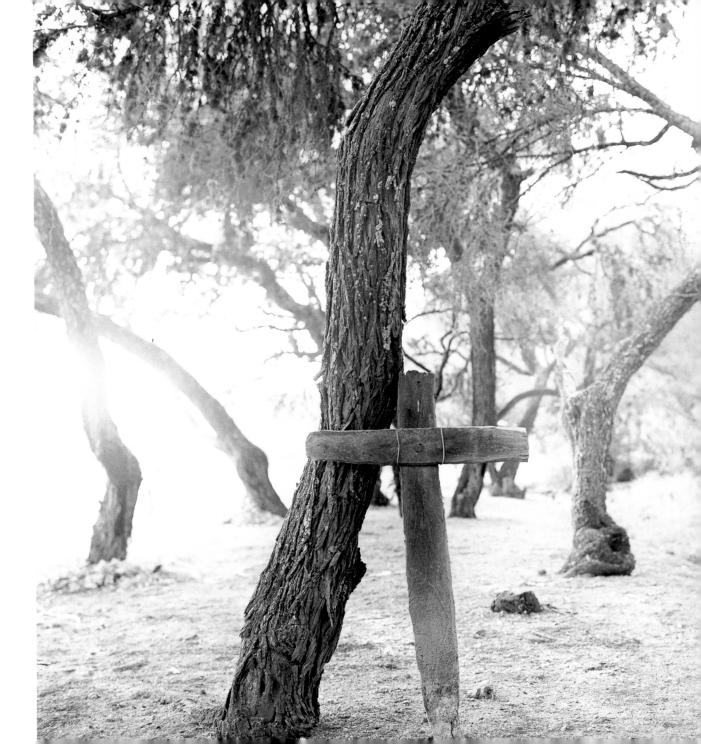

RANCHO RICO, MEXICO

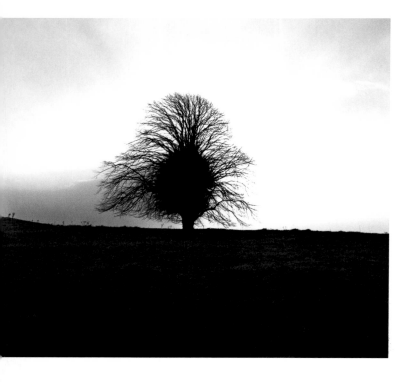

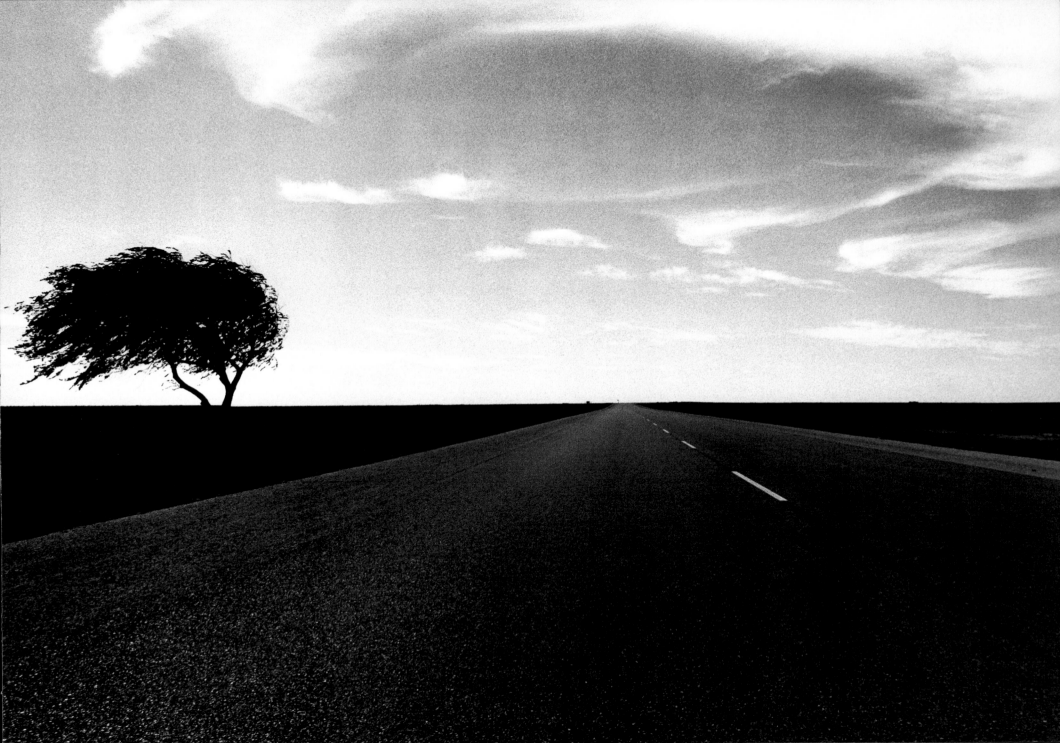

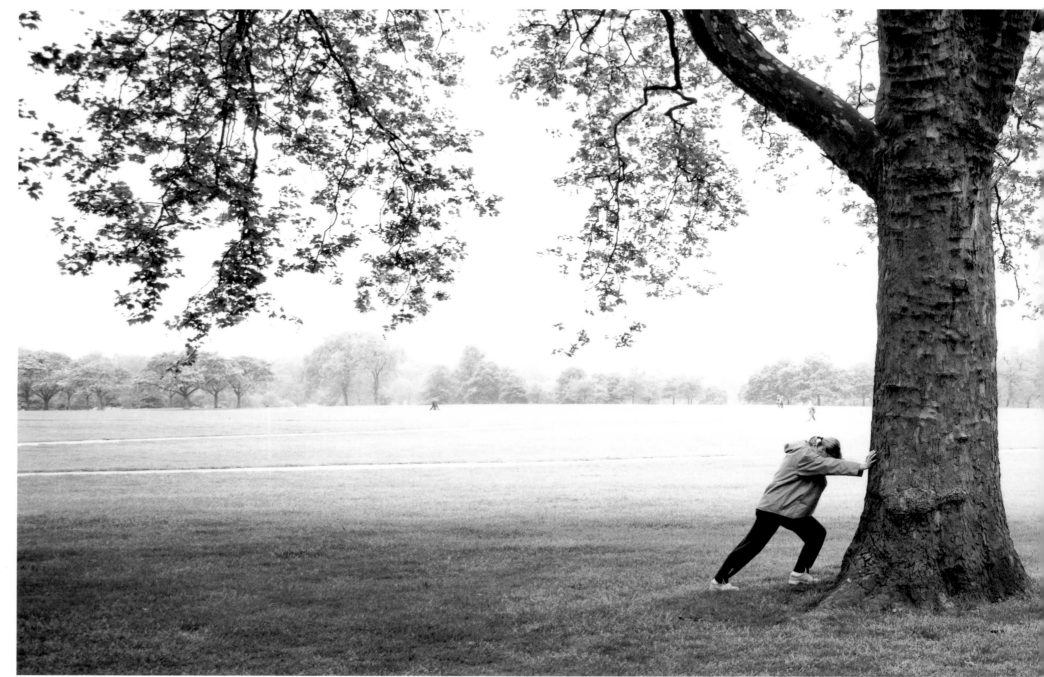

LONDON, ENGLAND

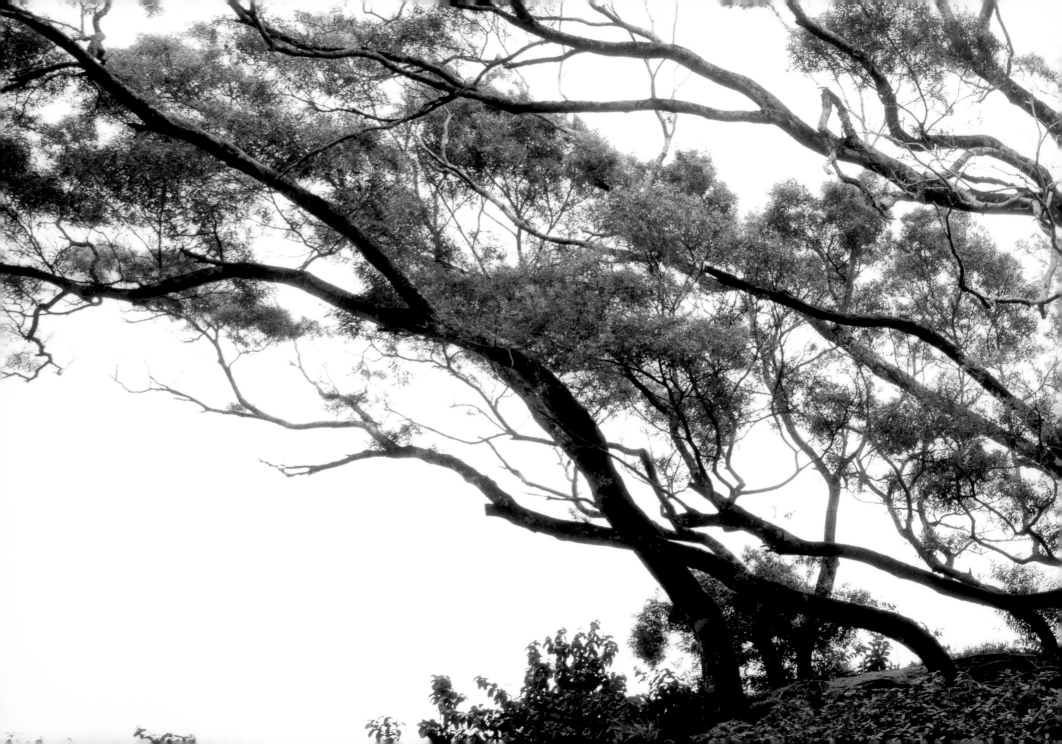

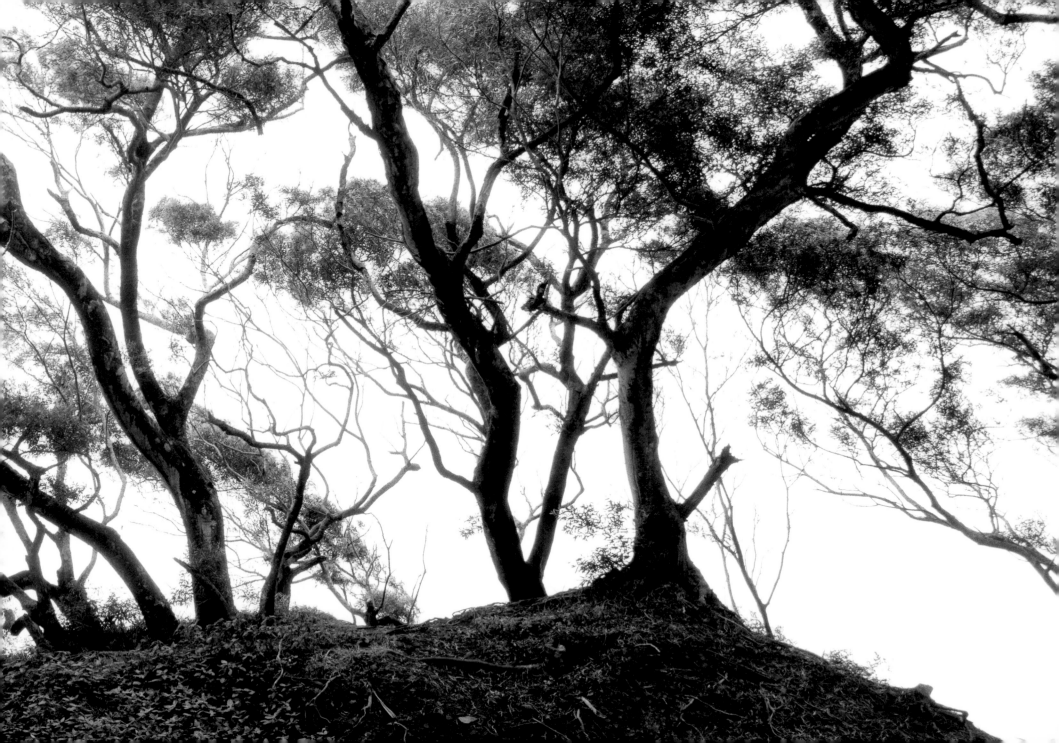

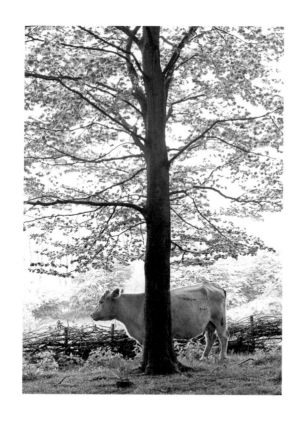

PARIS, FRANCE ▶

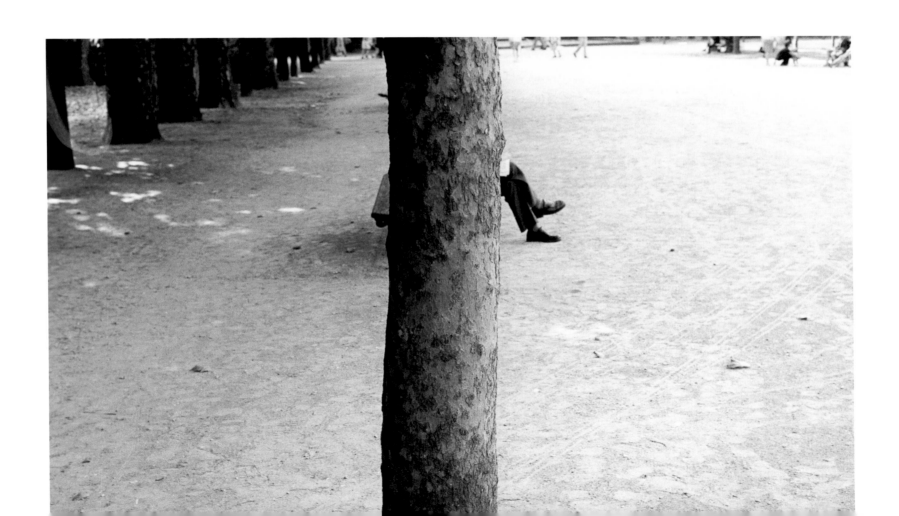

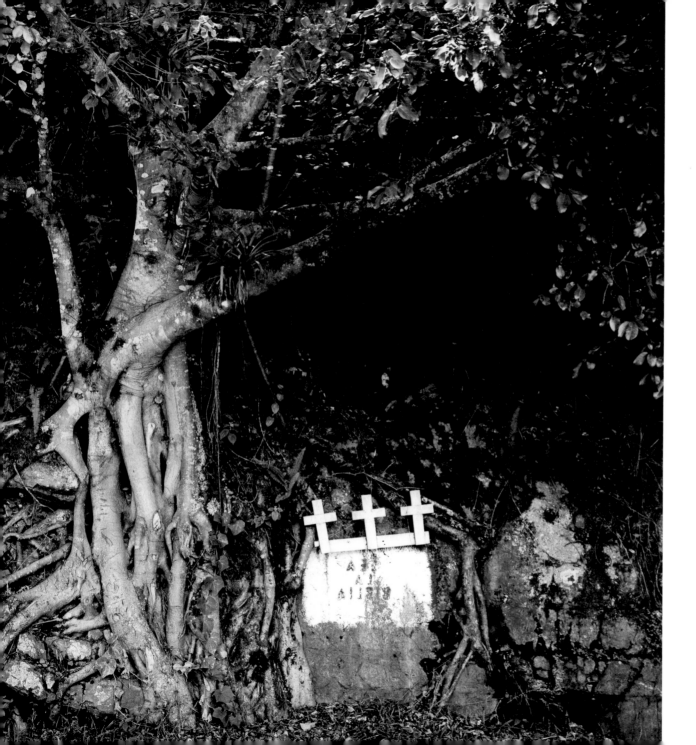

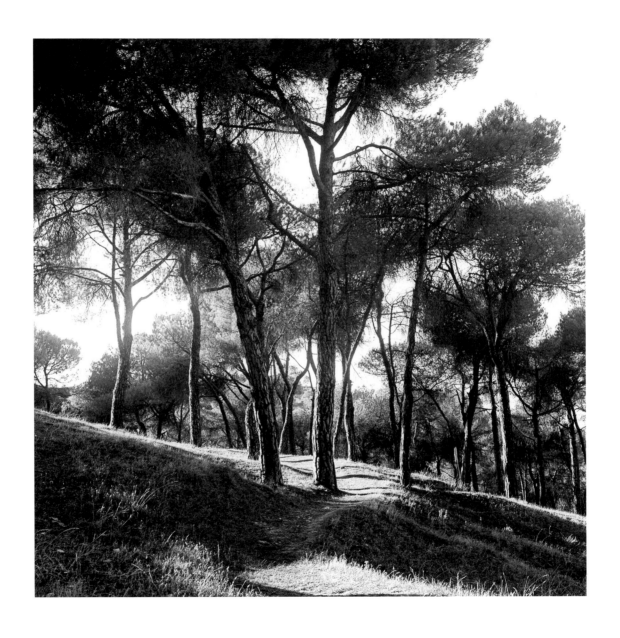

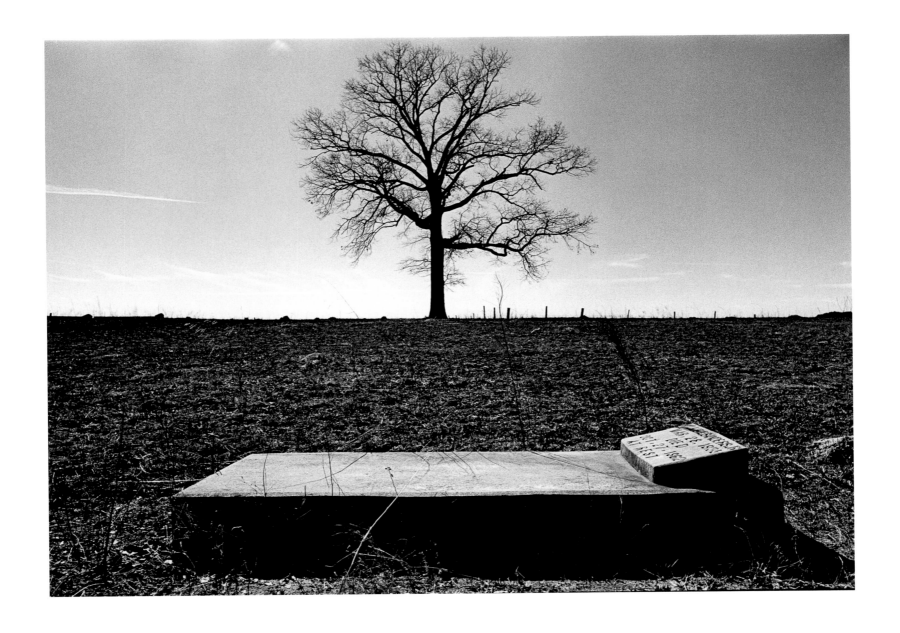

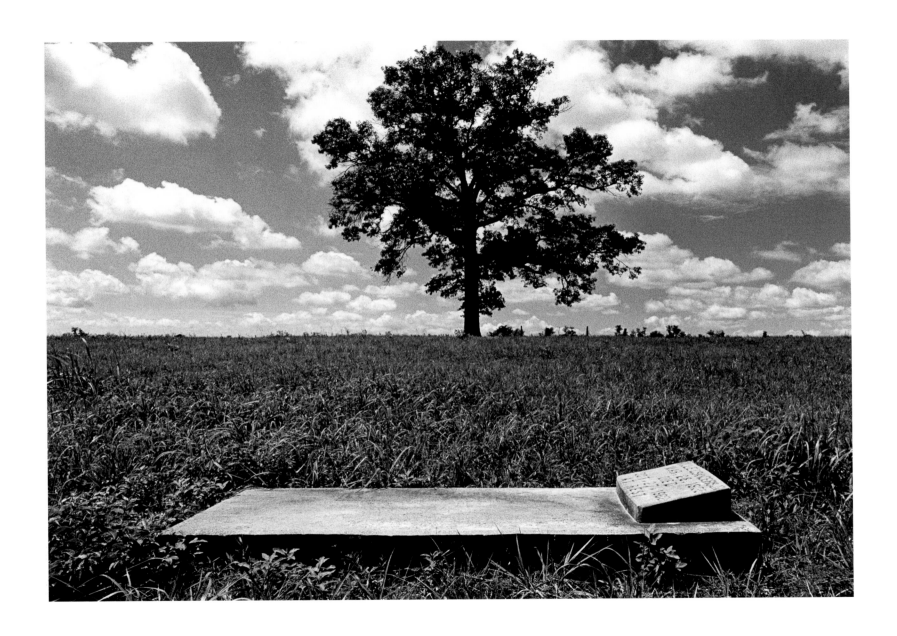

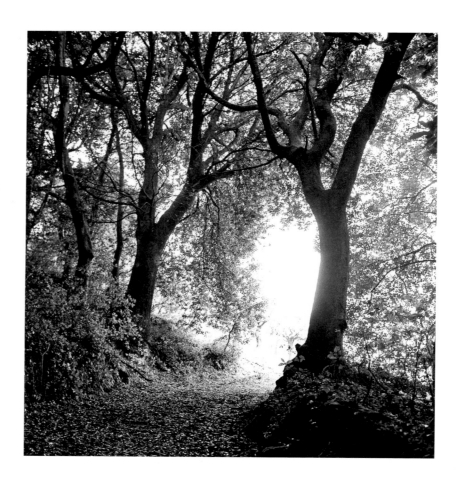

▲ CHIANTI, ITALY

OLYMPIC PENINSULA, WASHINGTON ▶

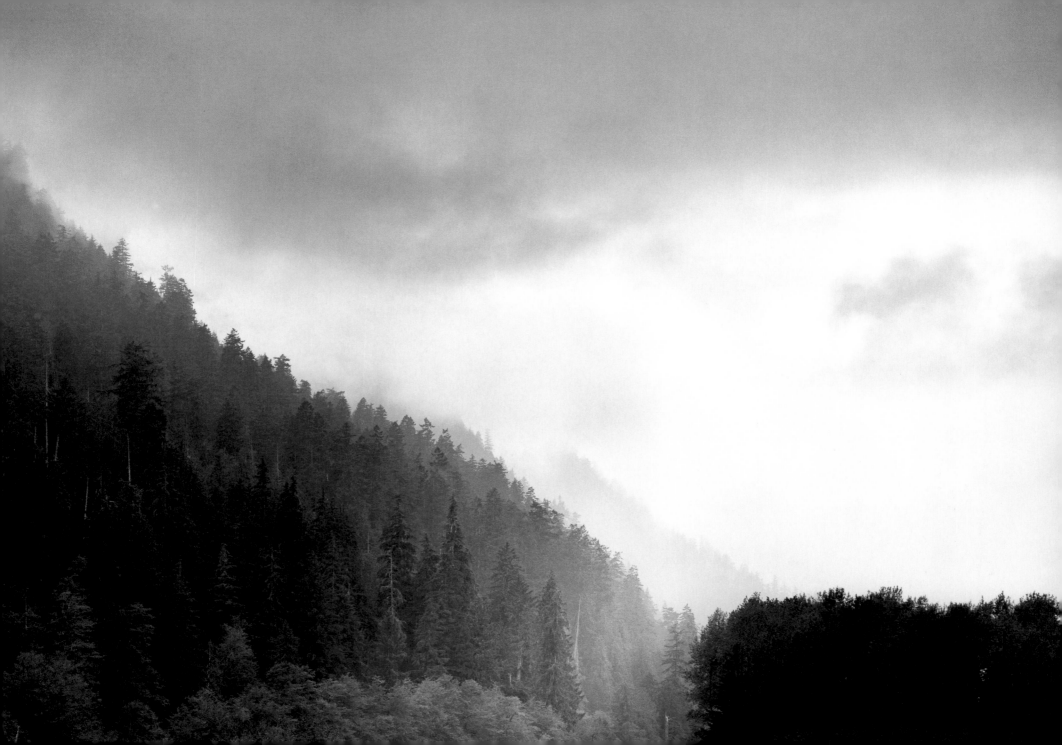

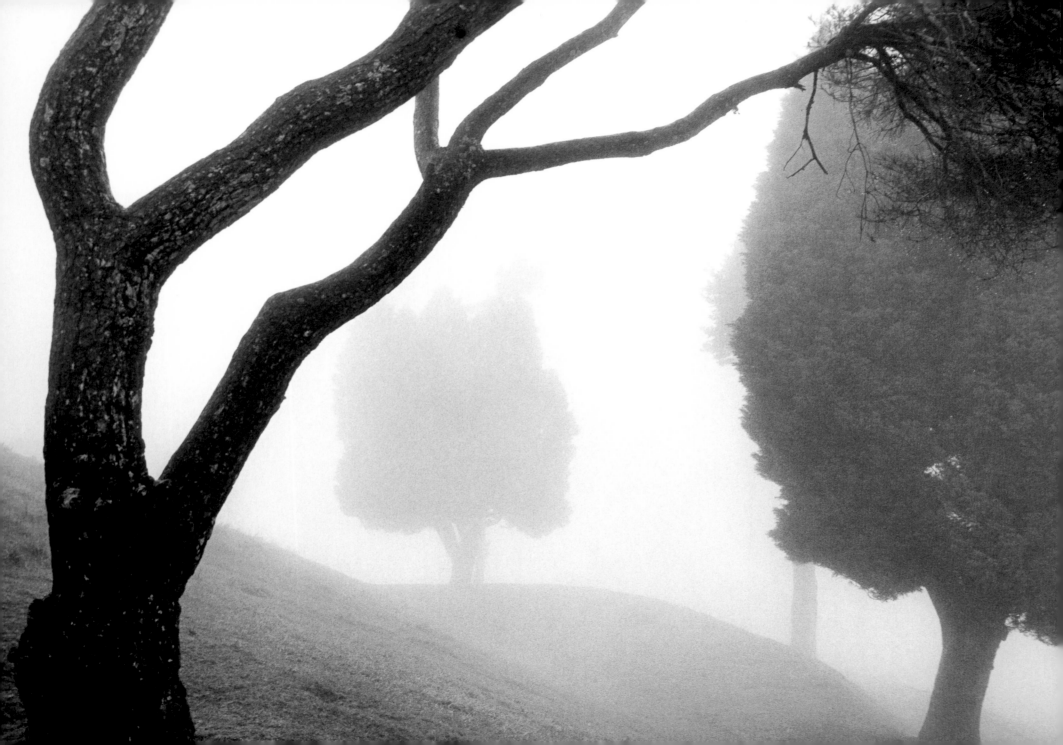

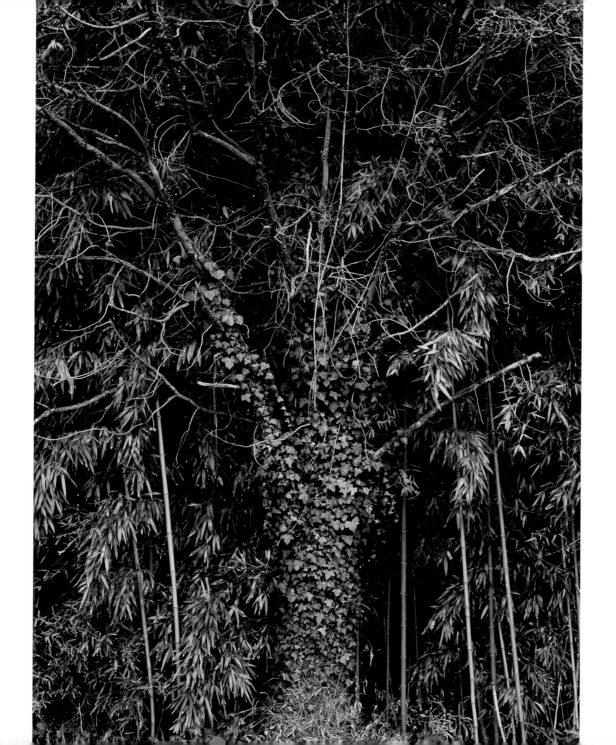

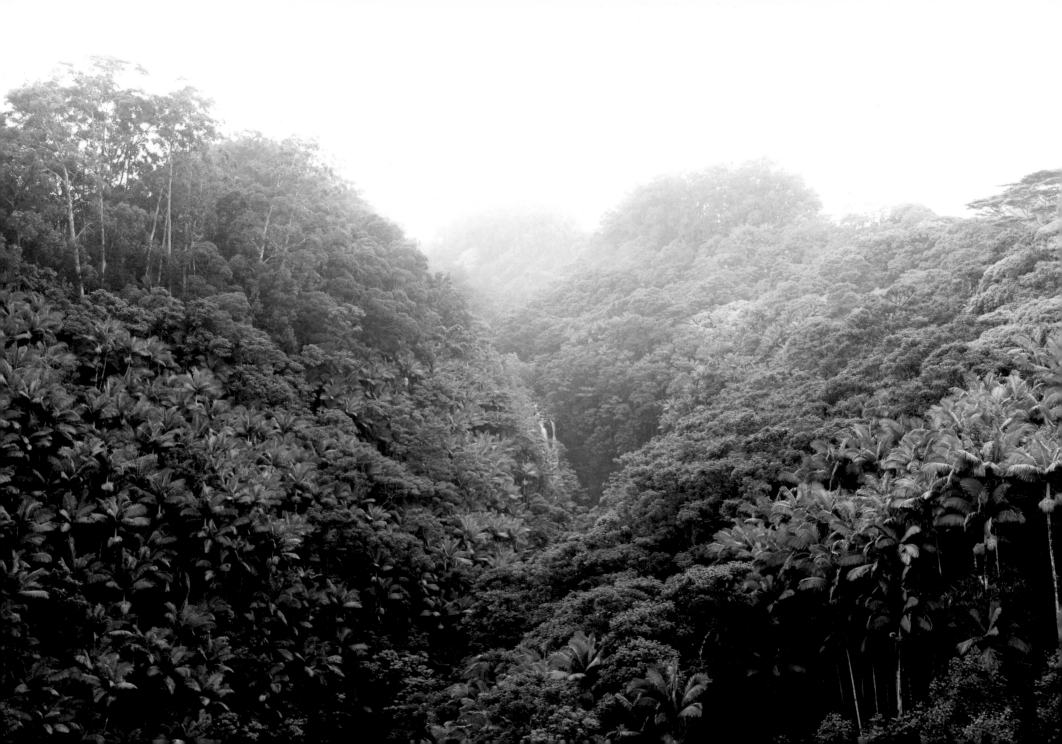

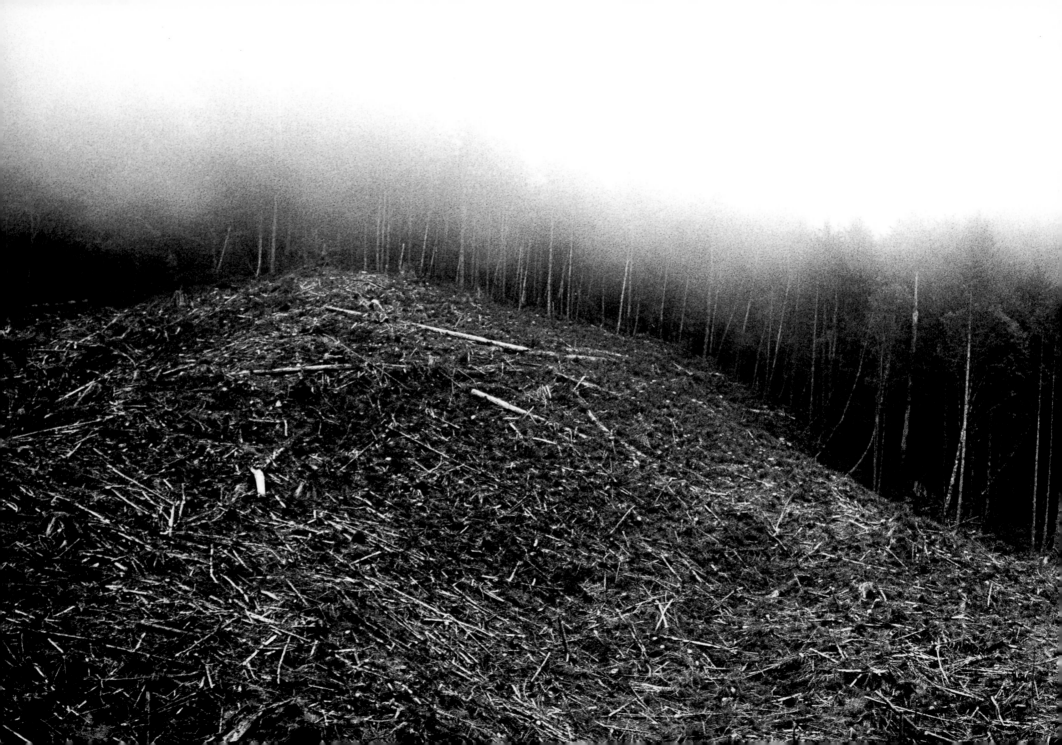

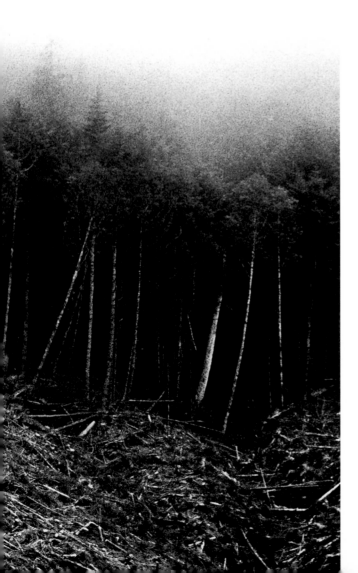

OLYMPIC PENINSULA, WASHINGTON

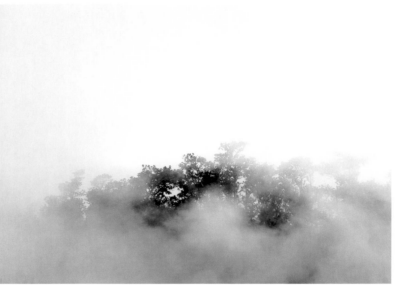

▲ BIG ISLAND, HAWAII ▶

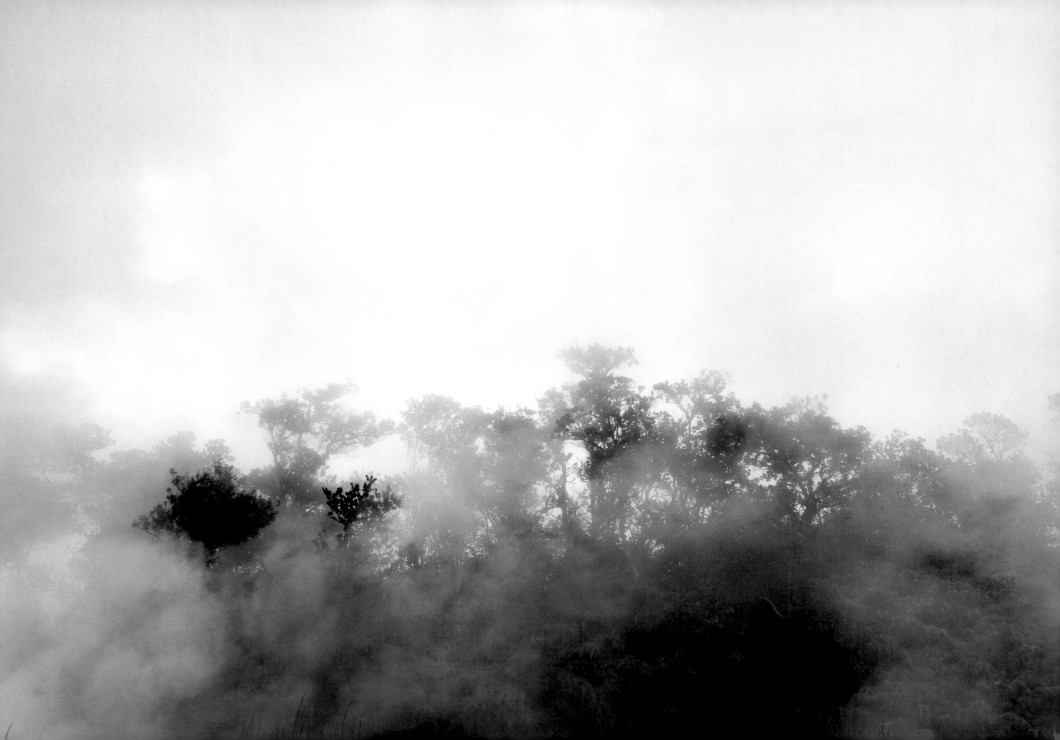

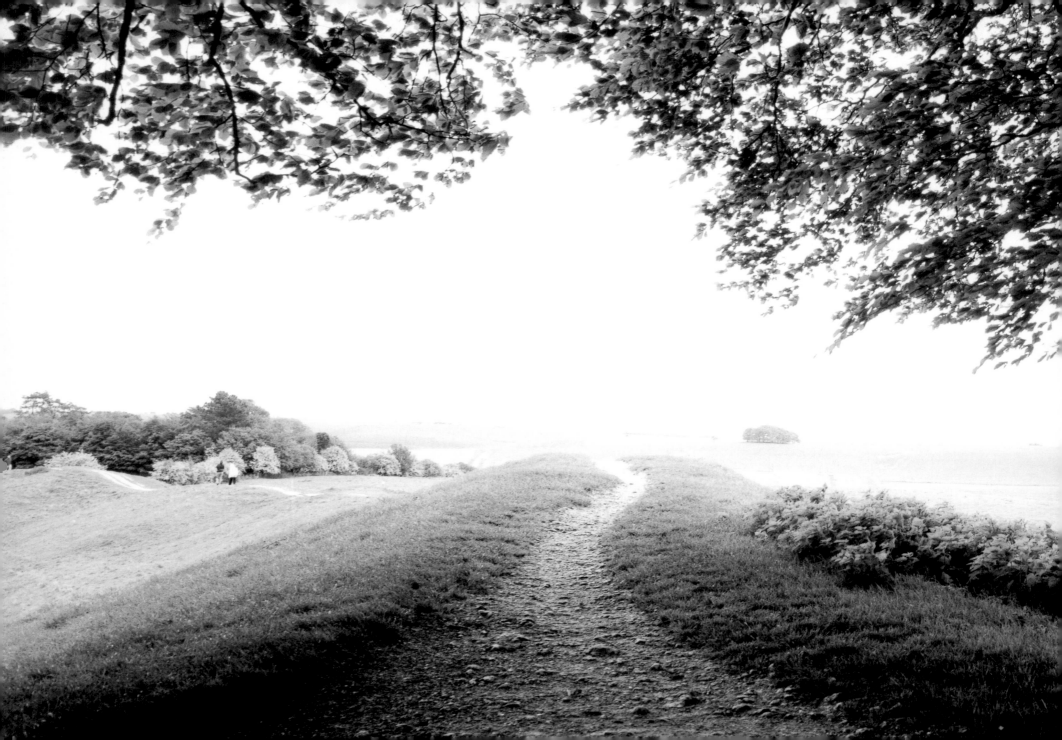

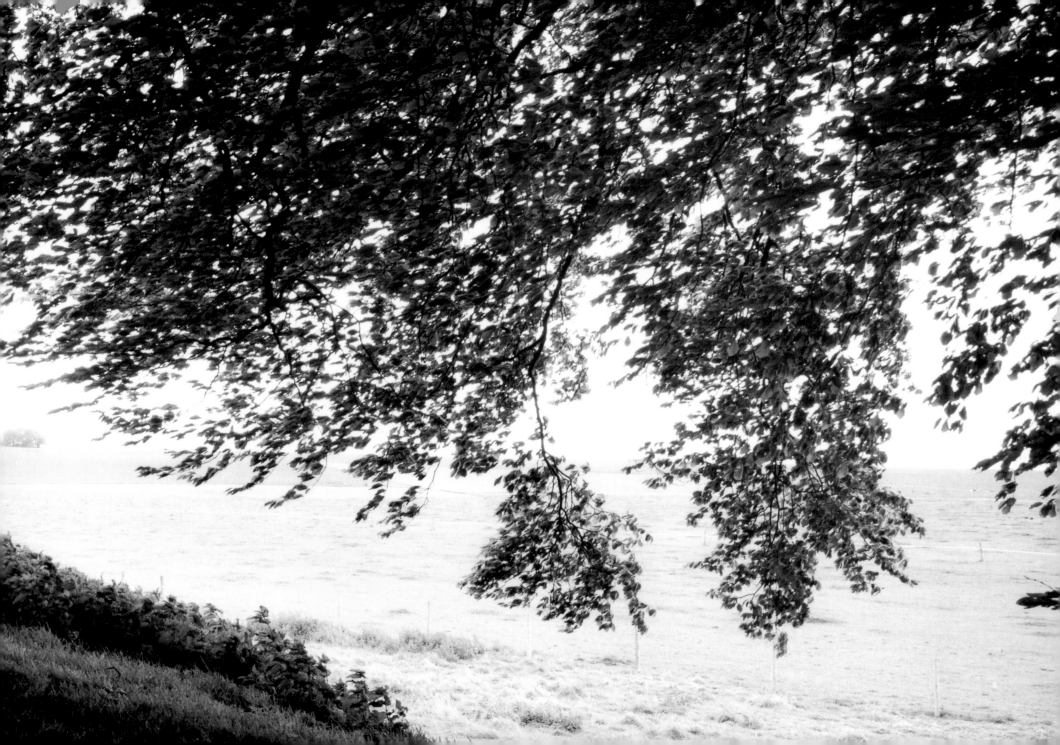

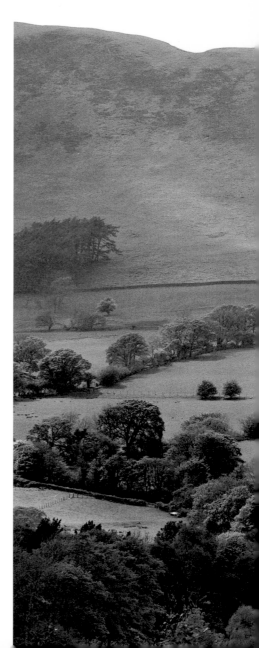

LAKE DISTRICT, ENGLAND

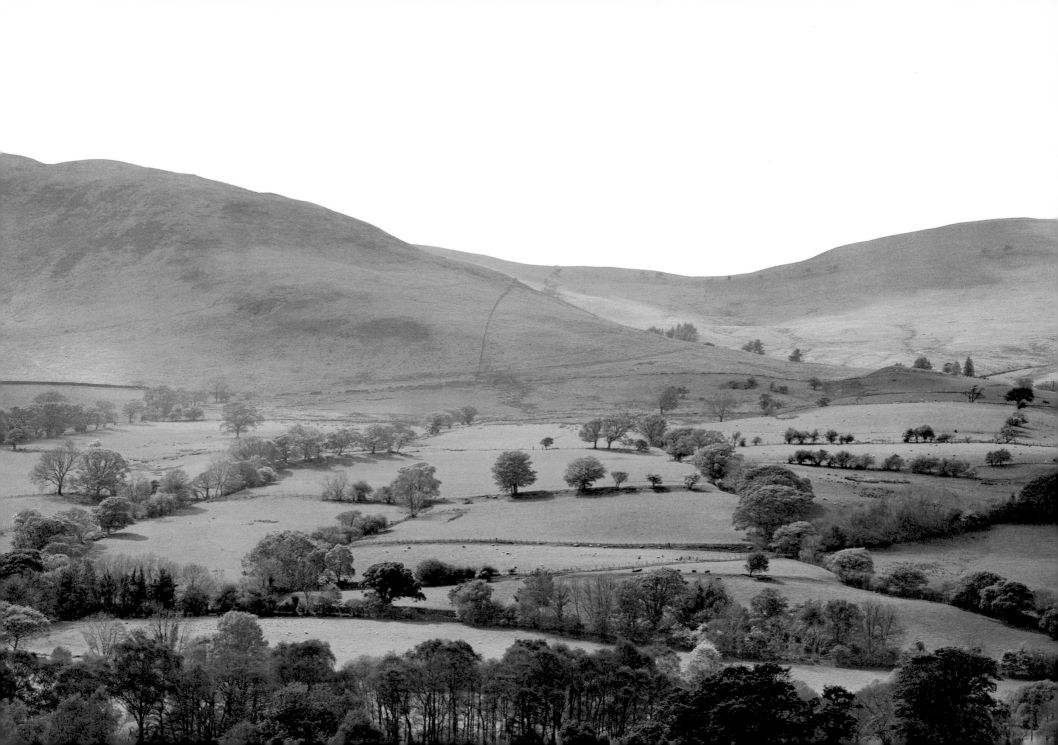

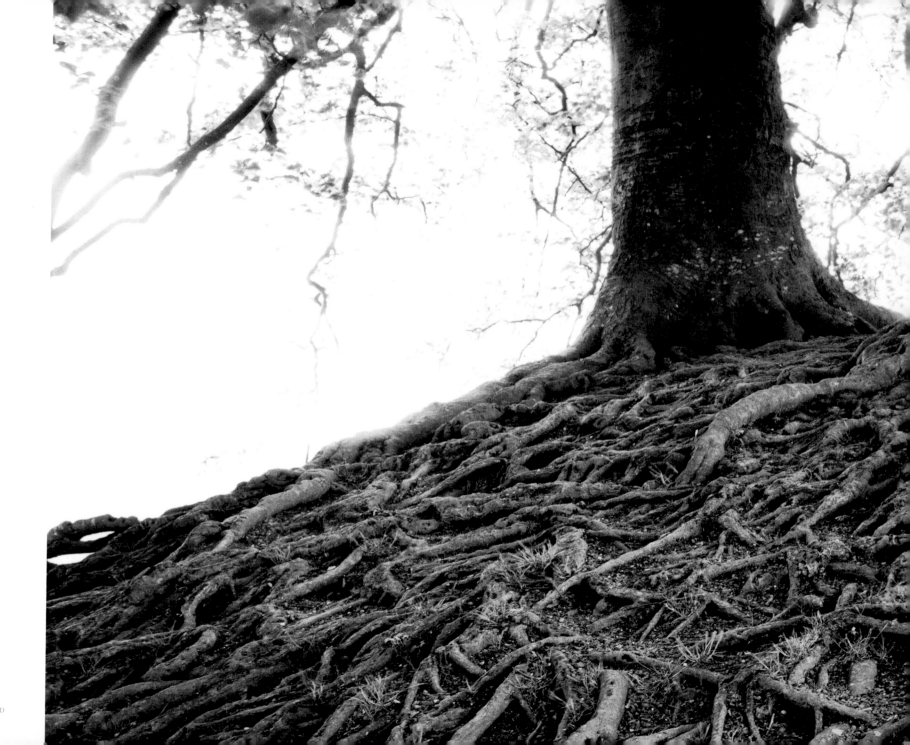

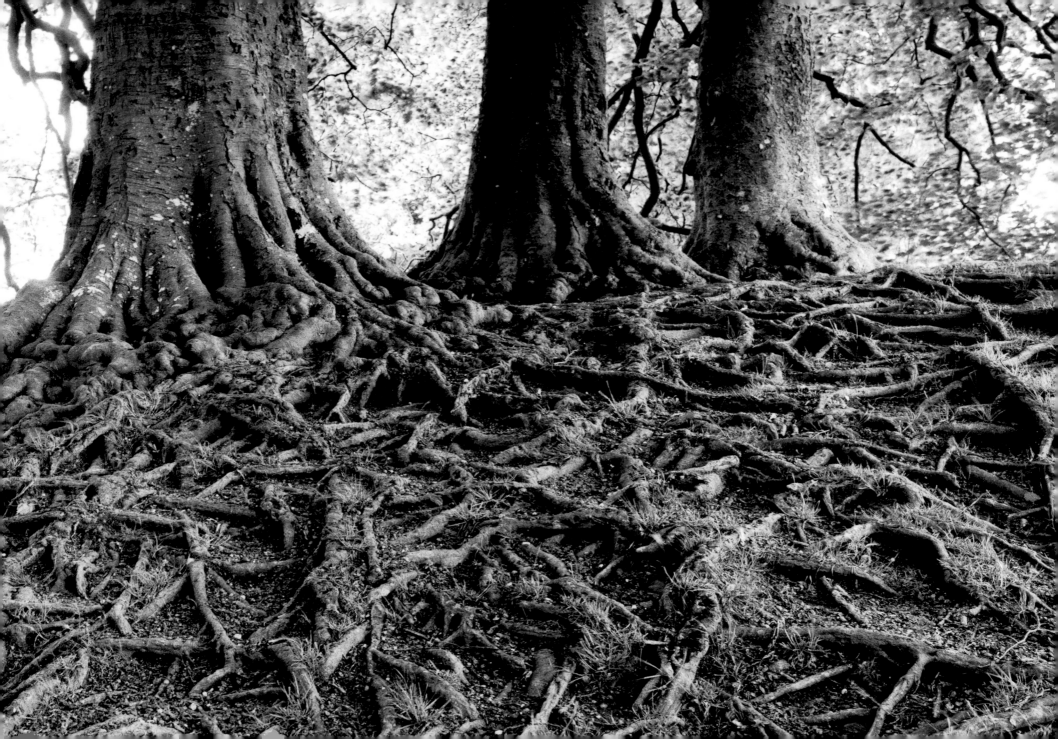

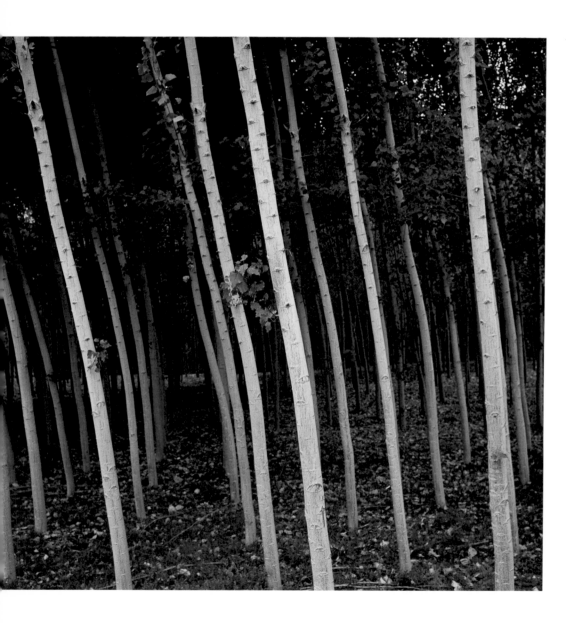

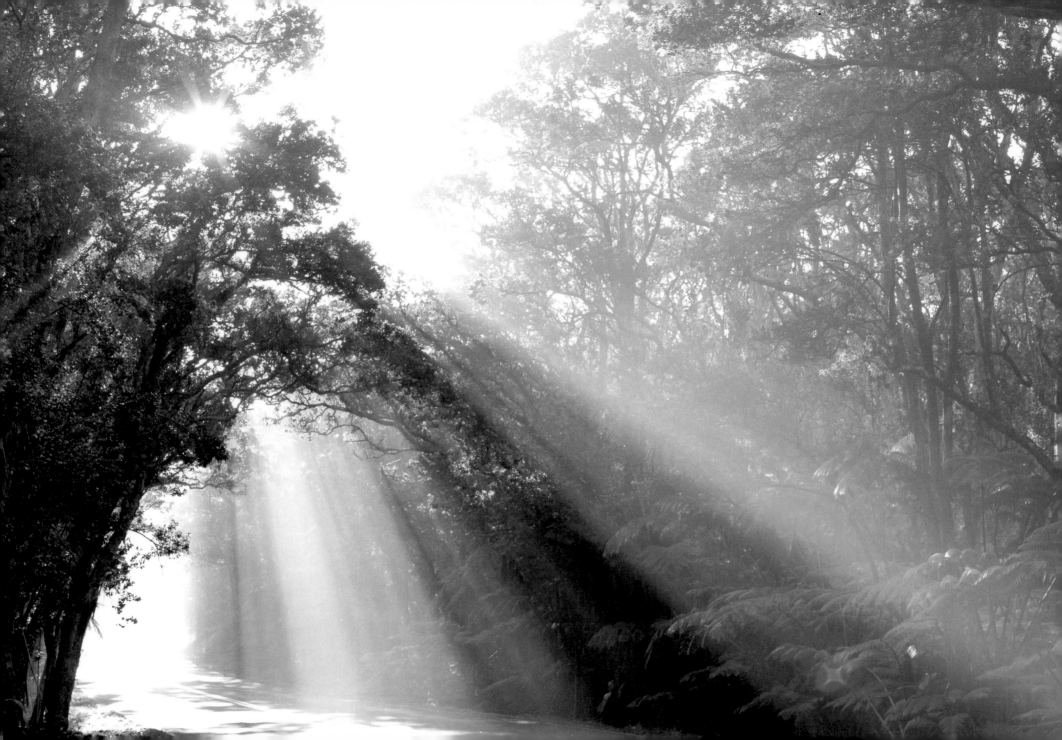

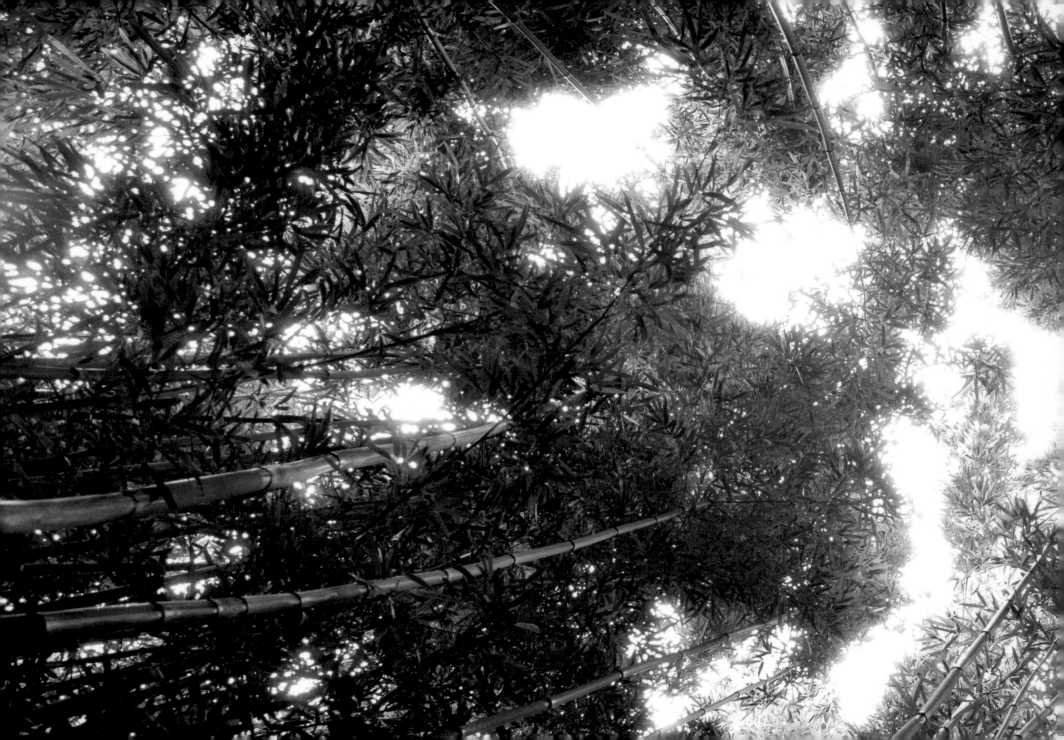

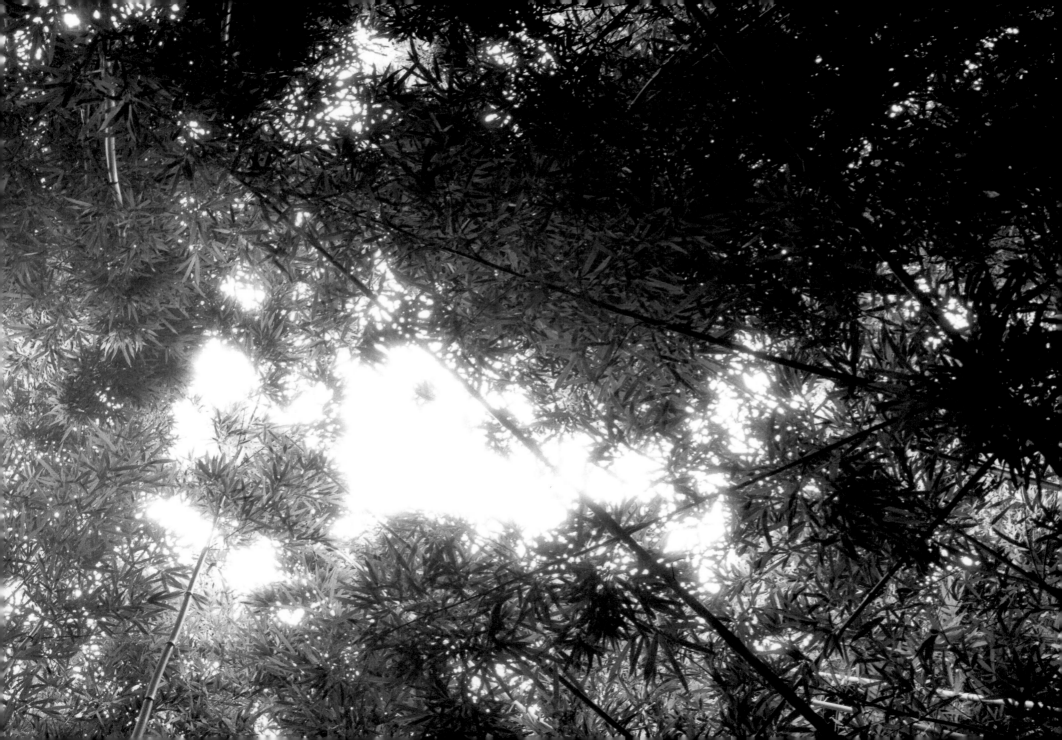

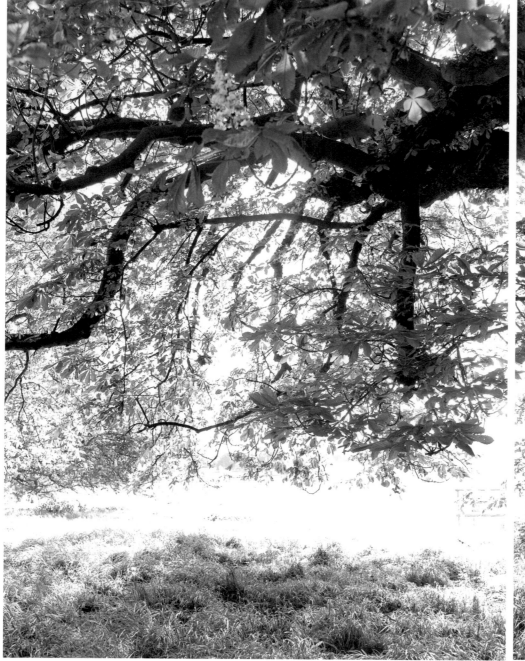
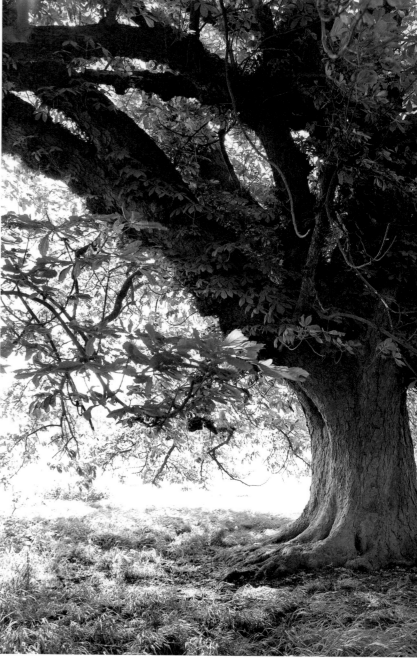

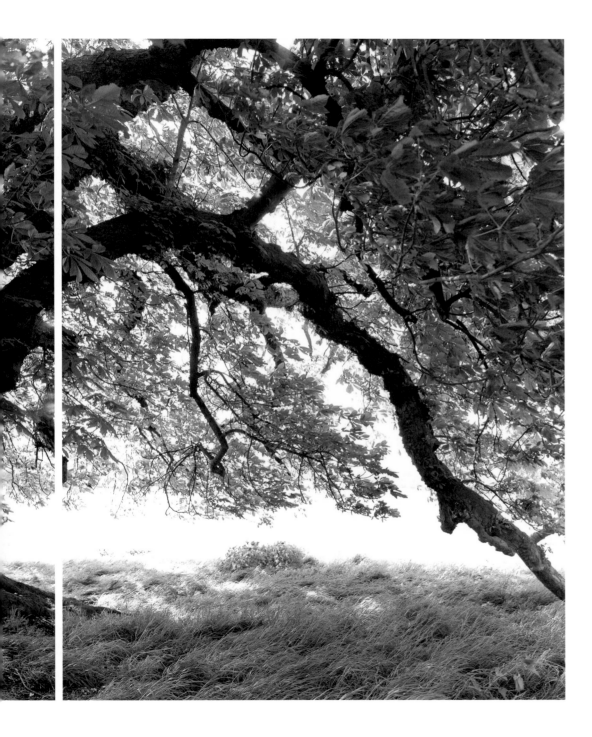

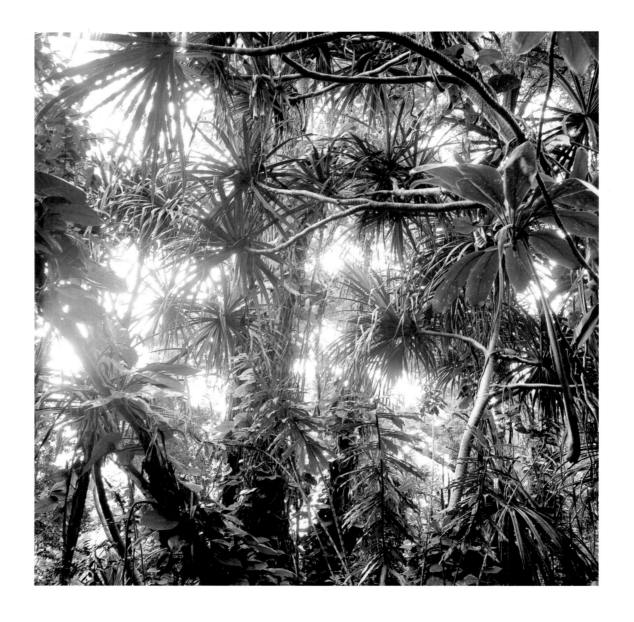

▲ BIG ISLAND, HAWAII ▶

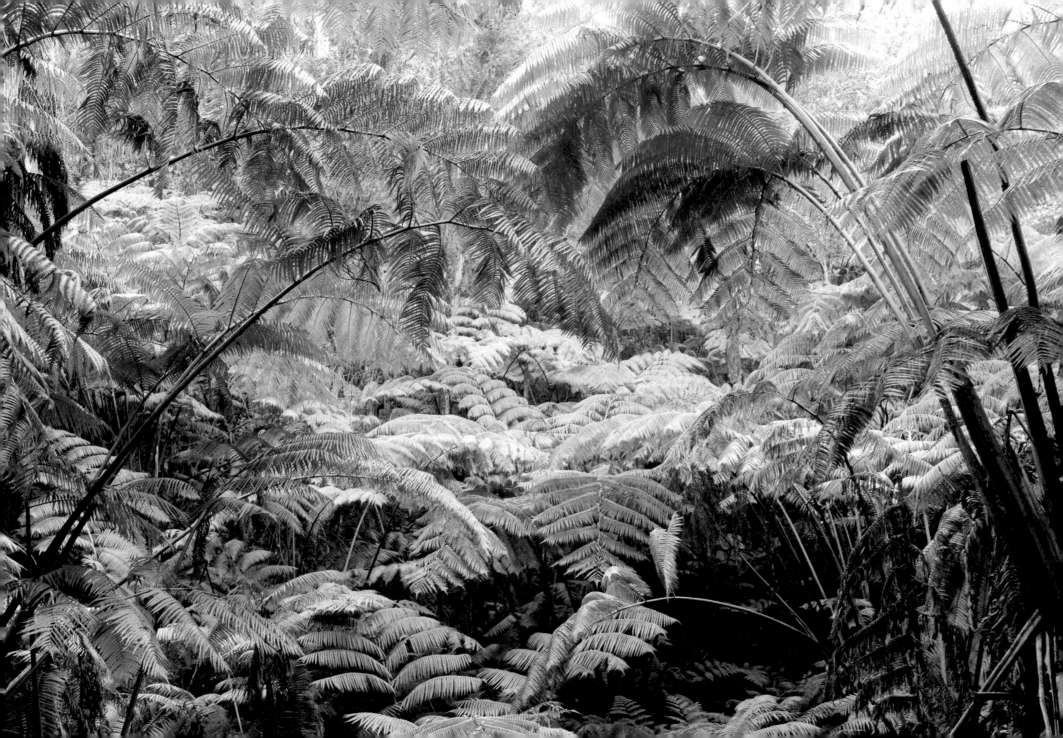

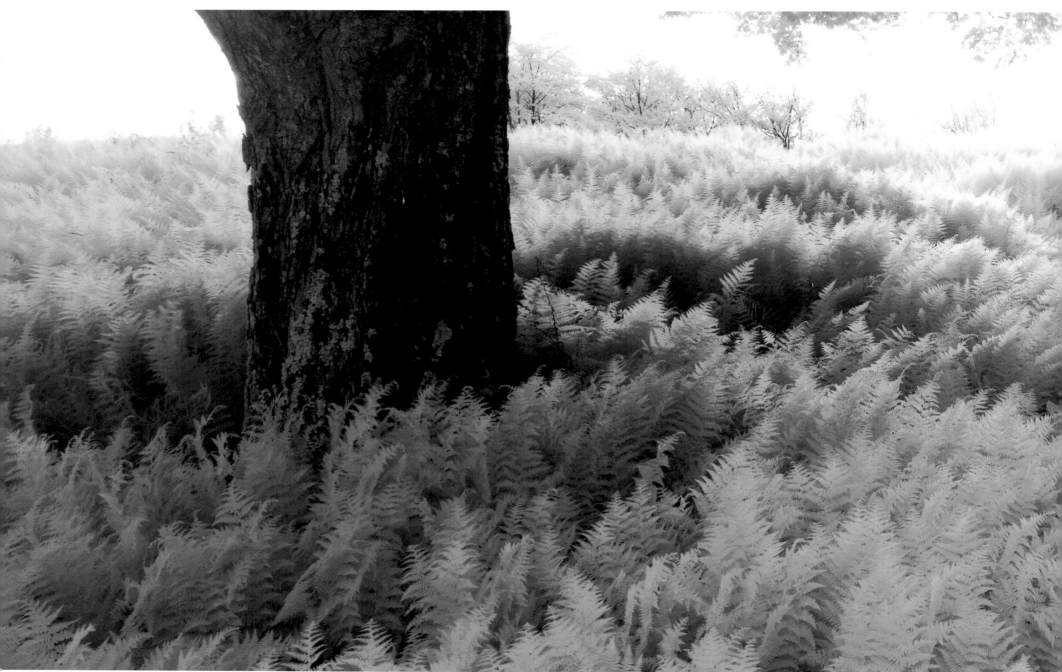

UPSTATE NEW YORK

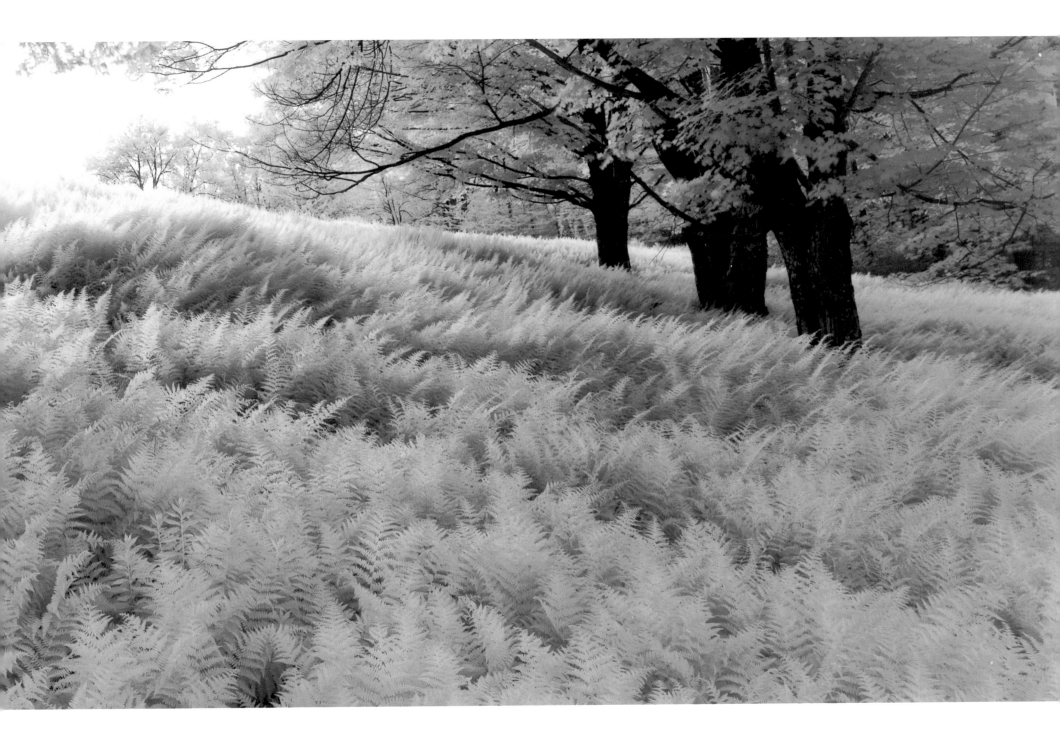

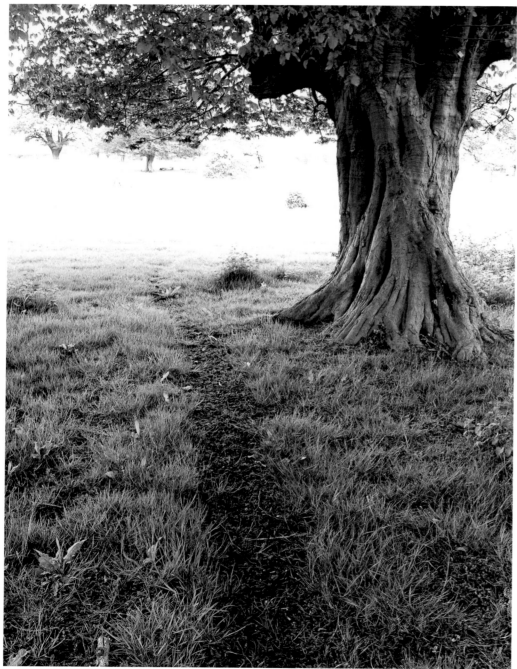

HATFIELD FOREST, ENGLAND

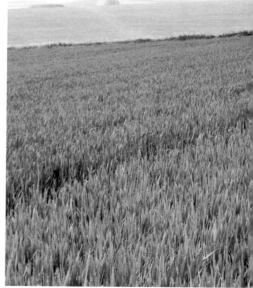

MARLBOROUGH DOWNS, ENGLAND

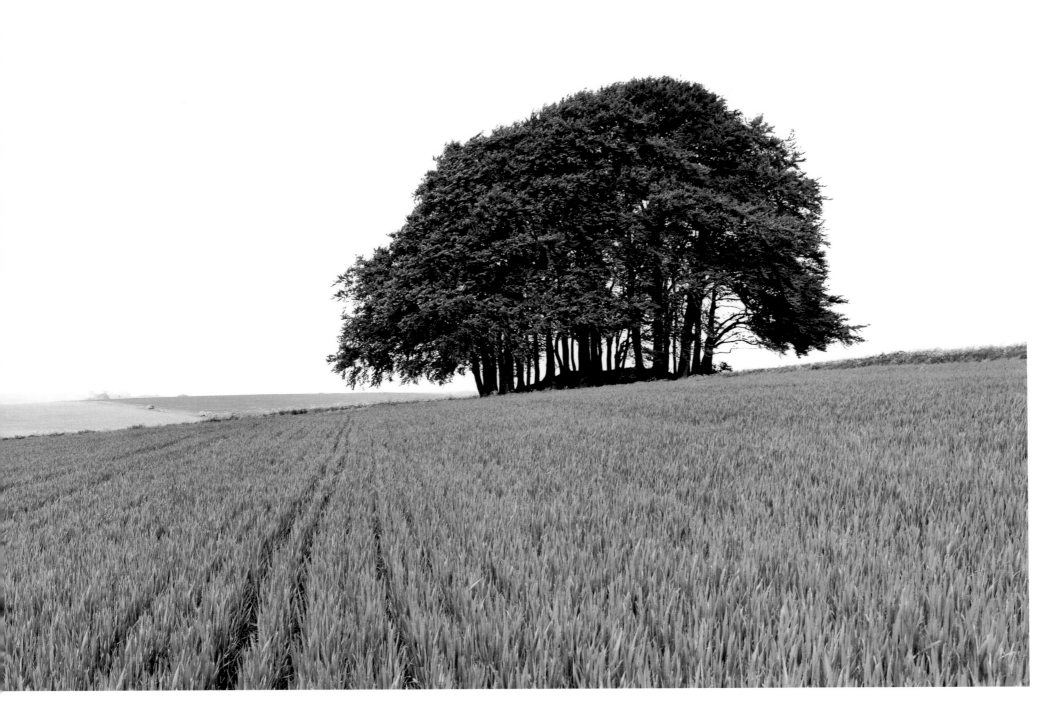

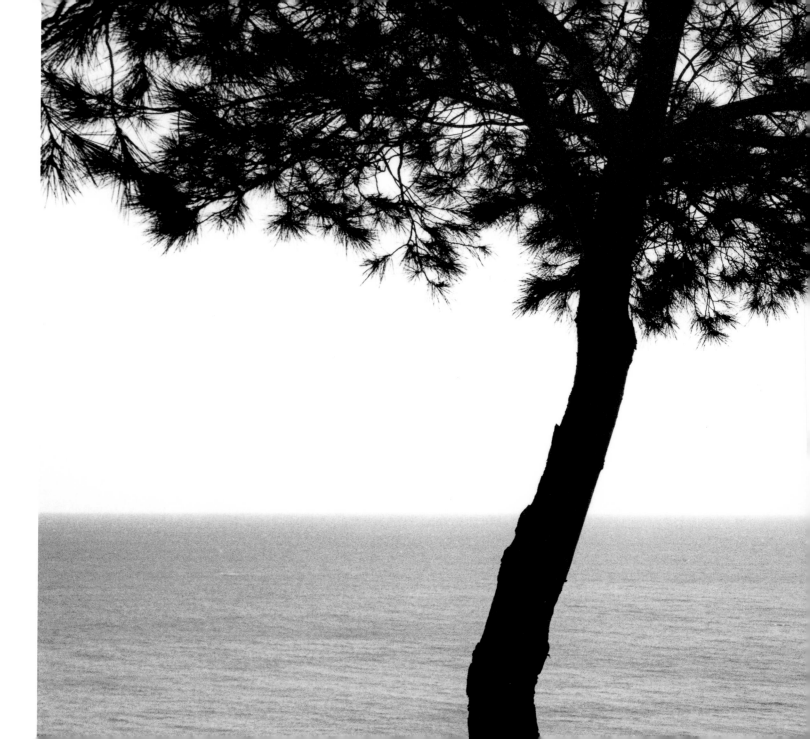

KASSÁNDRA PENINSULA, GREECE

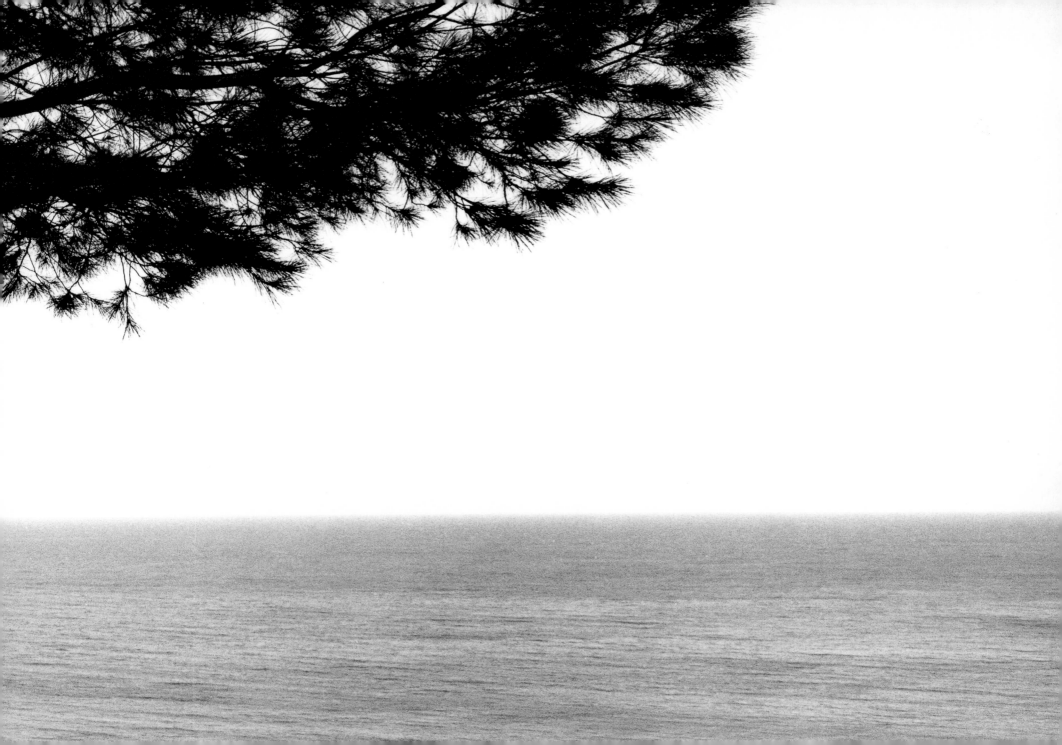

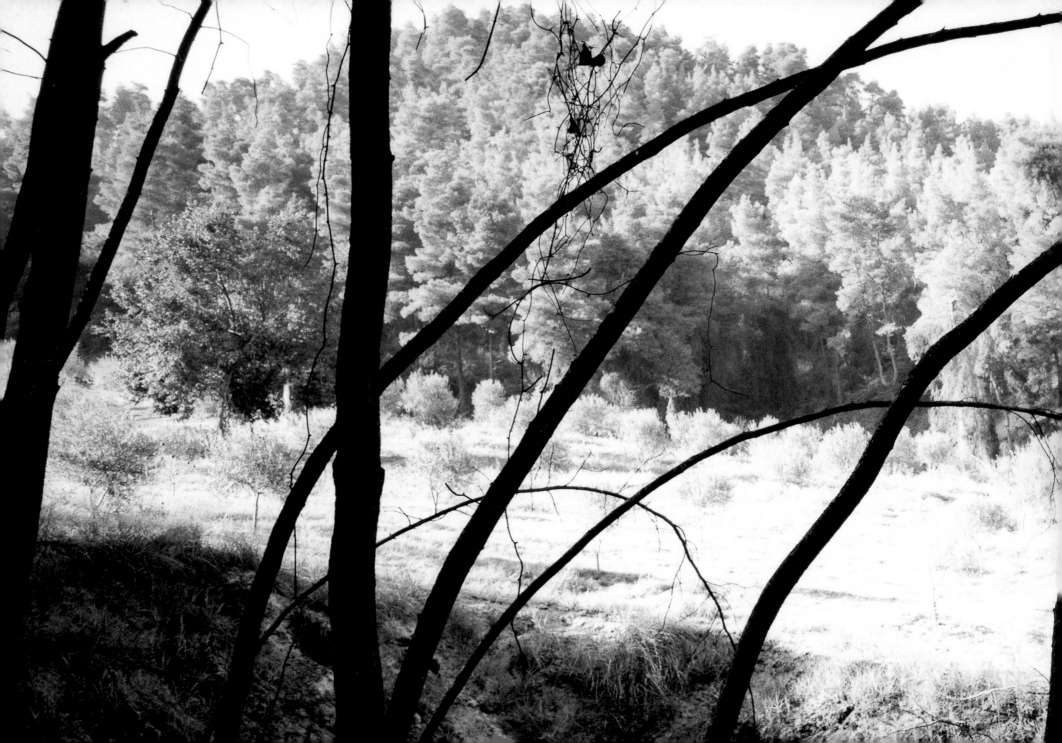

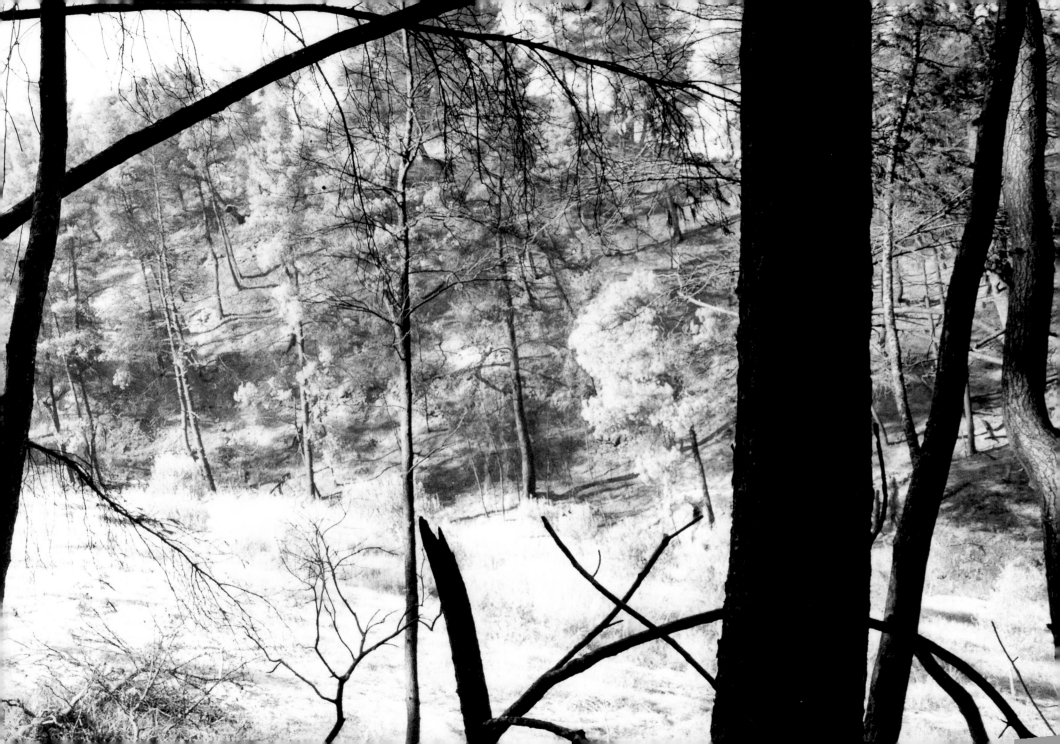

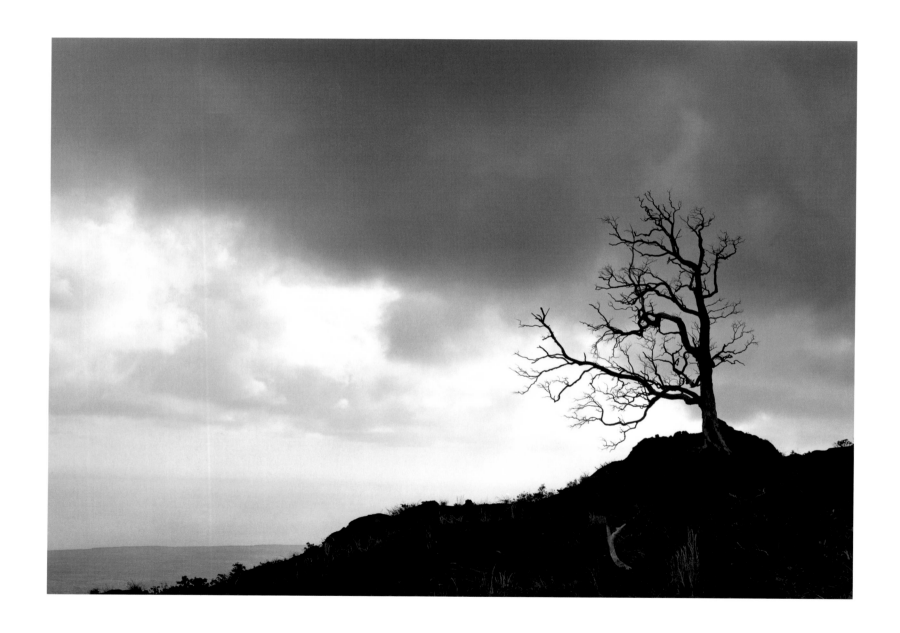

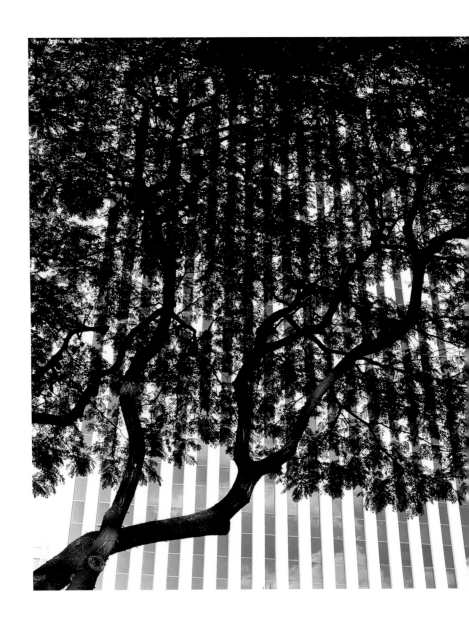

NEW YORK, NEW YORK

STONY CREEK, CONNECTICUT

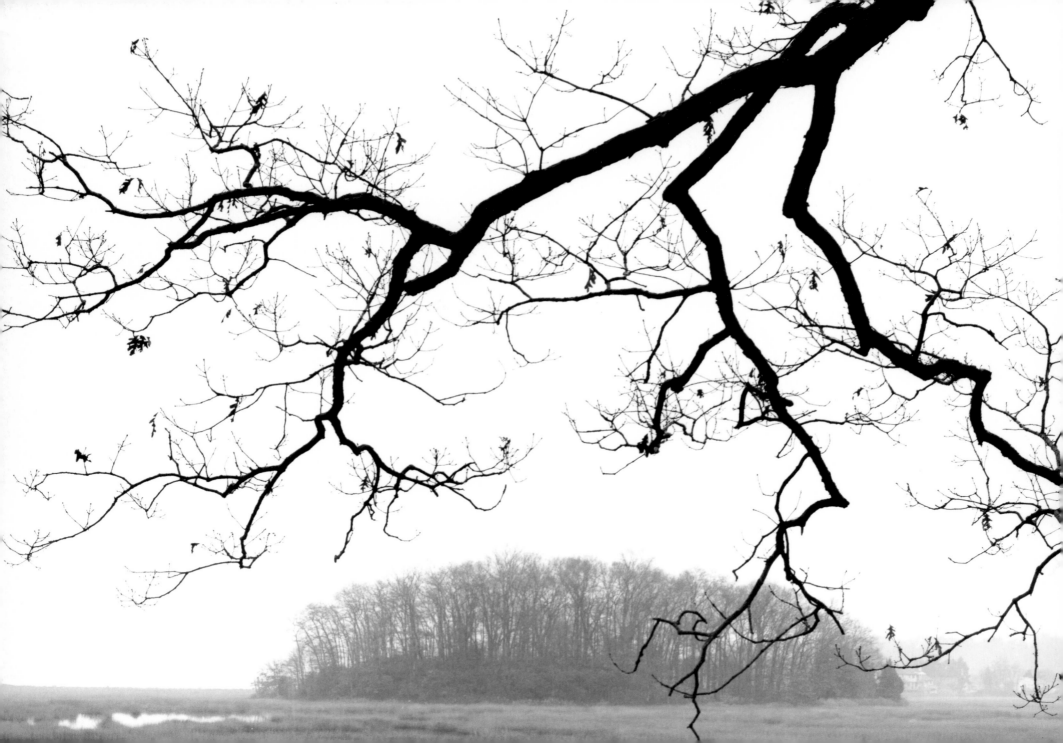

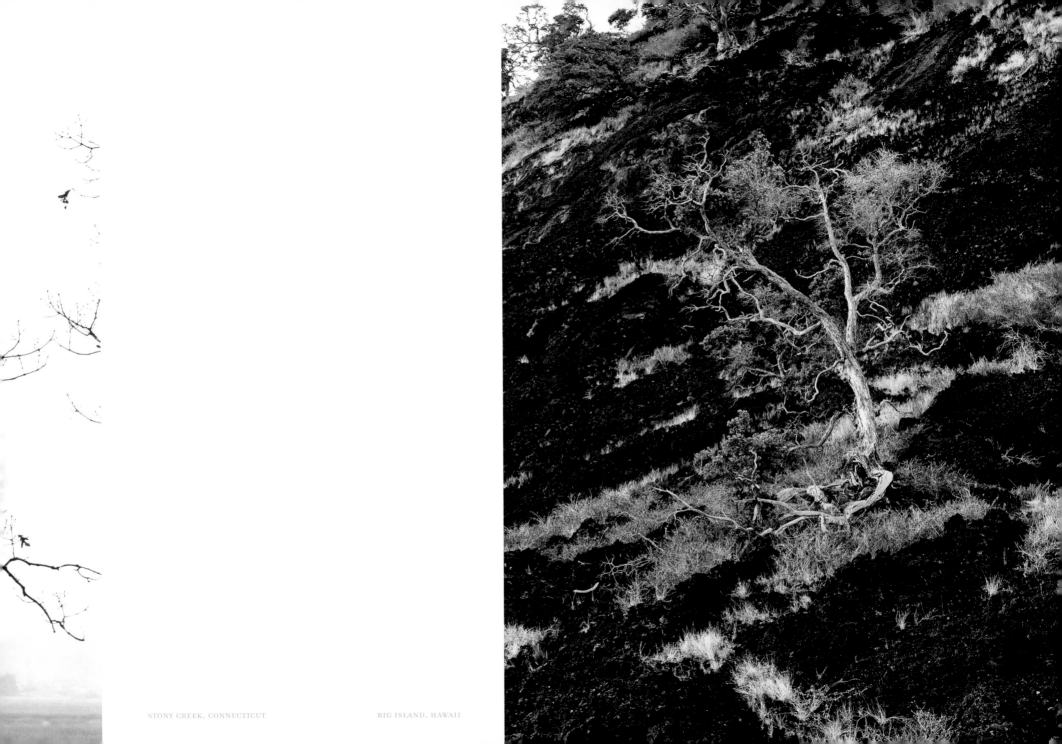

STONY CREEK, CONNECTICUT BIG ISLAND, HAWAII

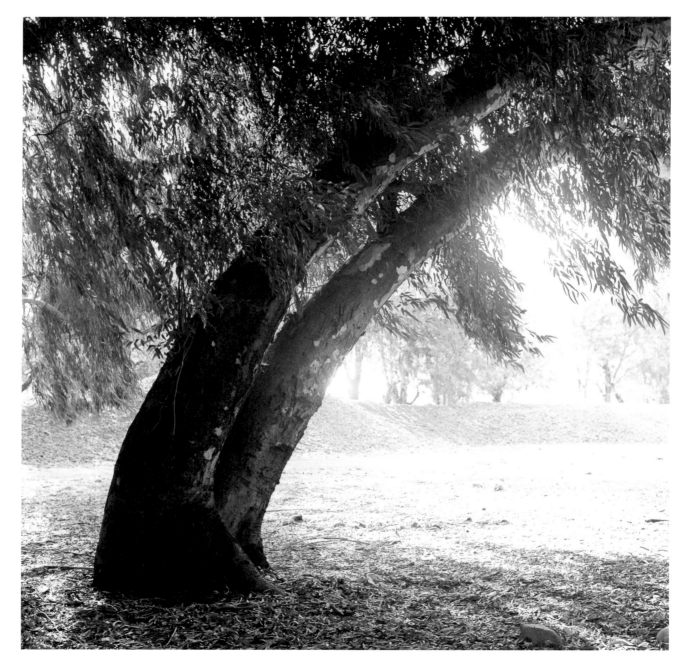

OLD CASTILE, SPAIN

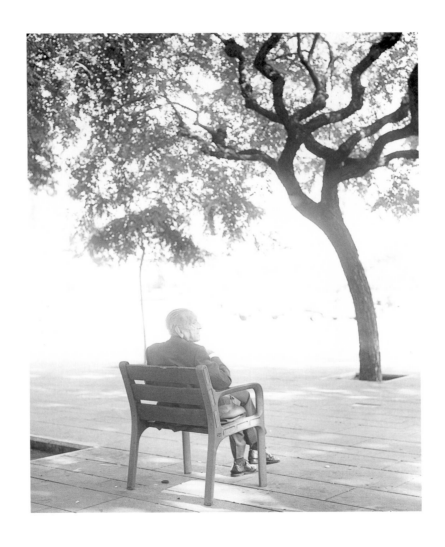

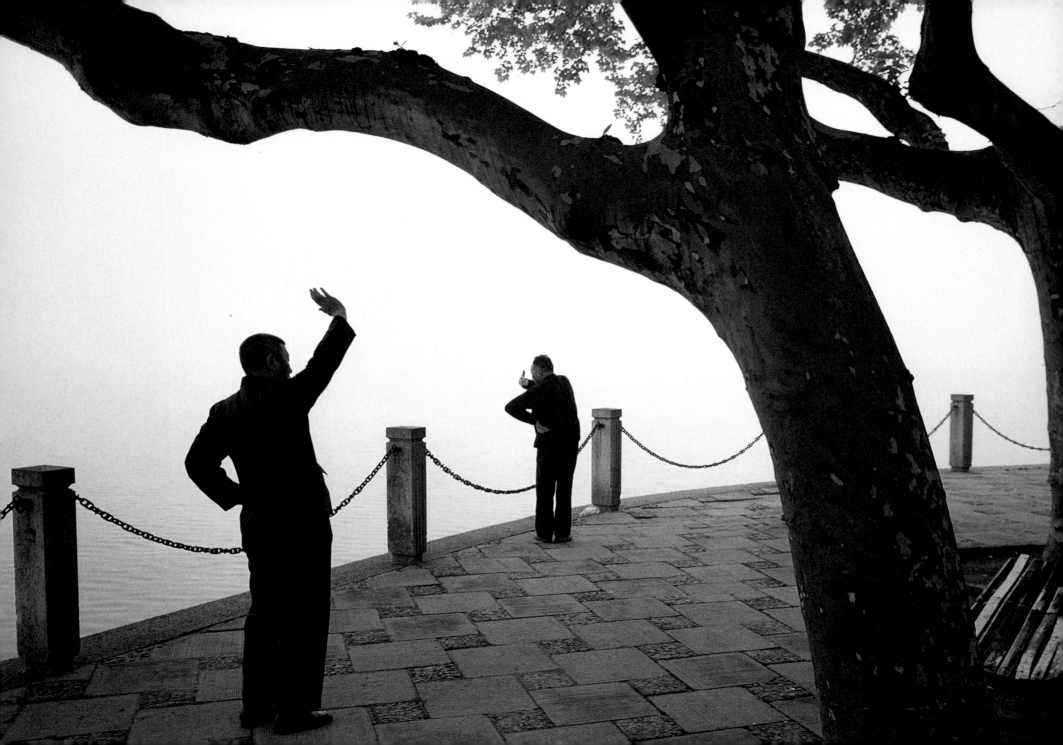

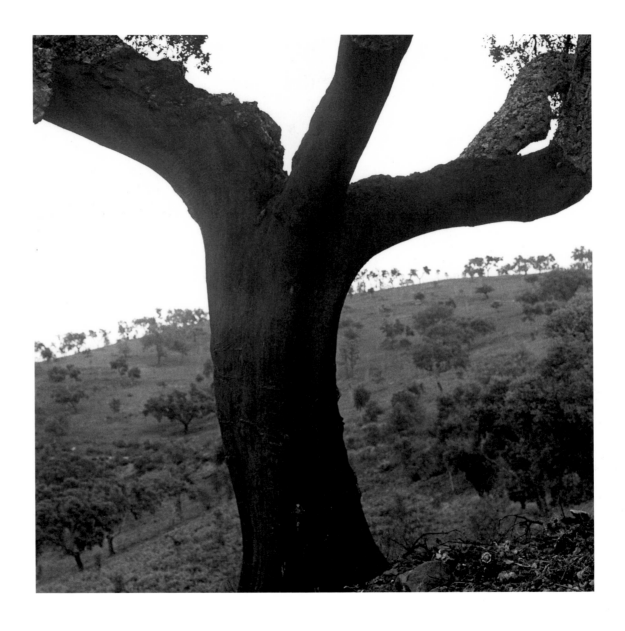

HANGZHOU, CHINA CASTILE, SPAIN 123

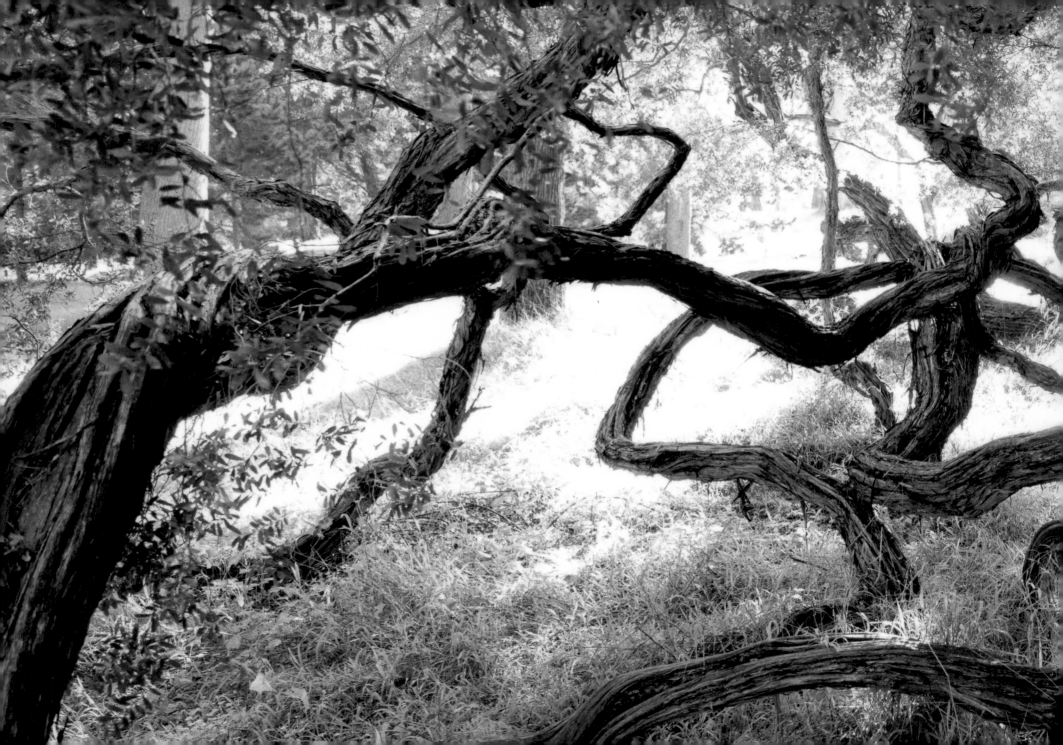

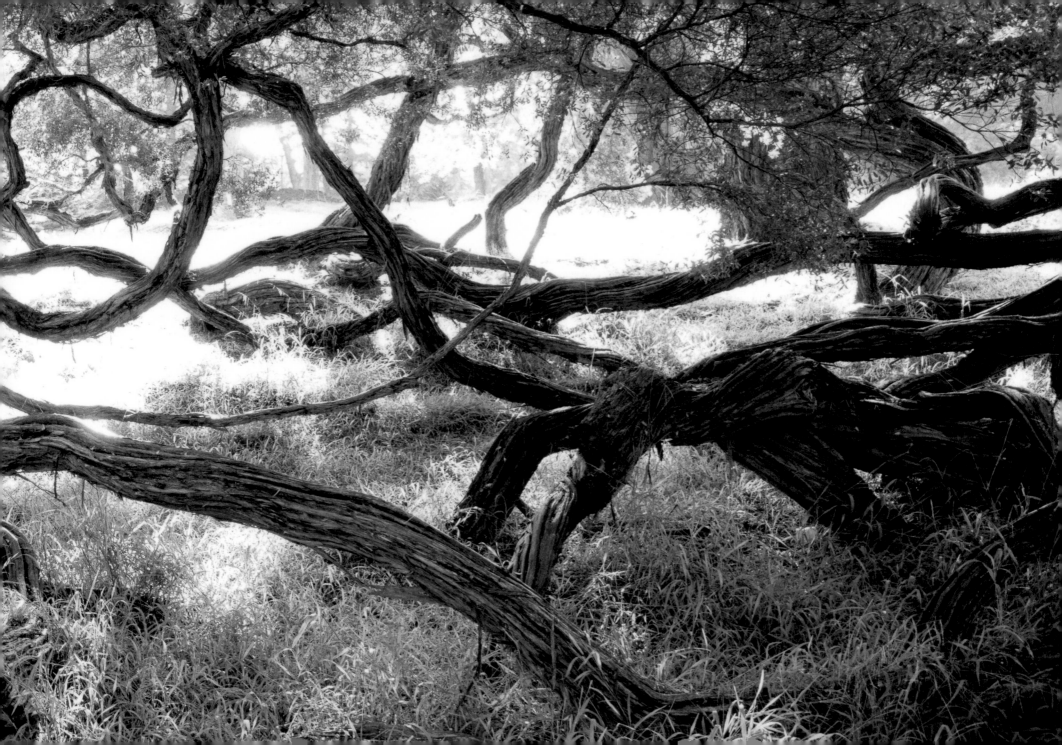

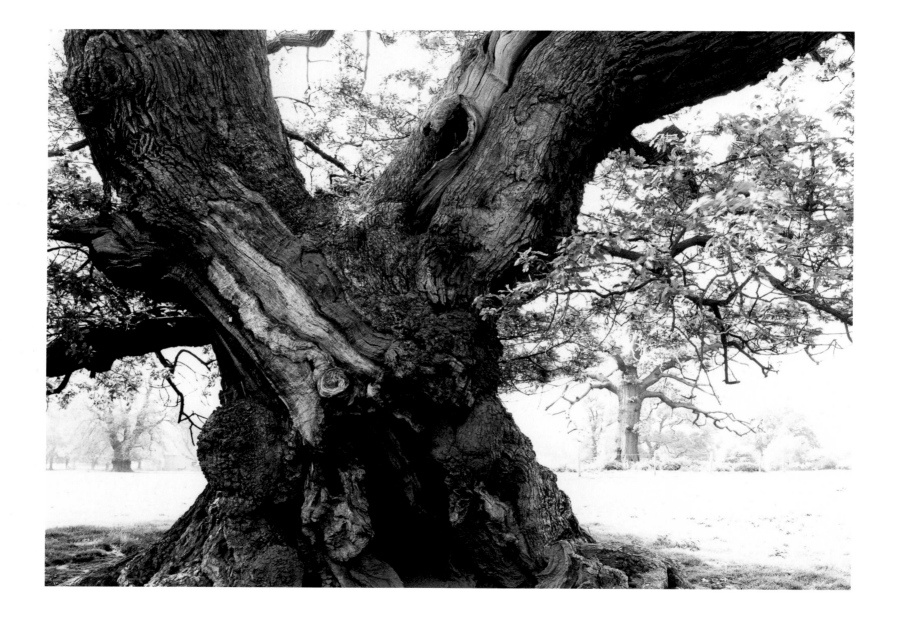

◀ SAN FRANCISCO, CALIFORNIA ▲ WEST MIDLANDS, ENGLAND SIERRA MOUNTAINS, CALIFORNIA ▶

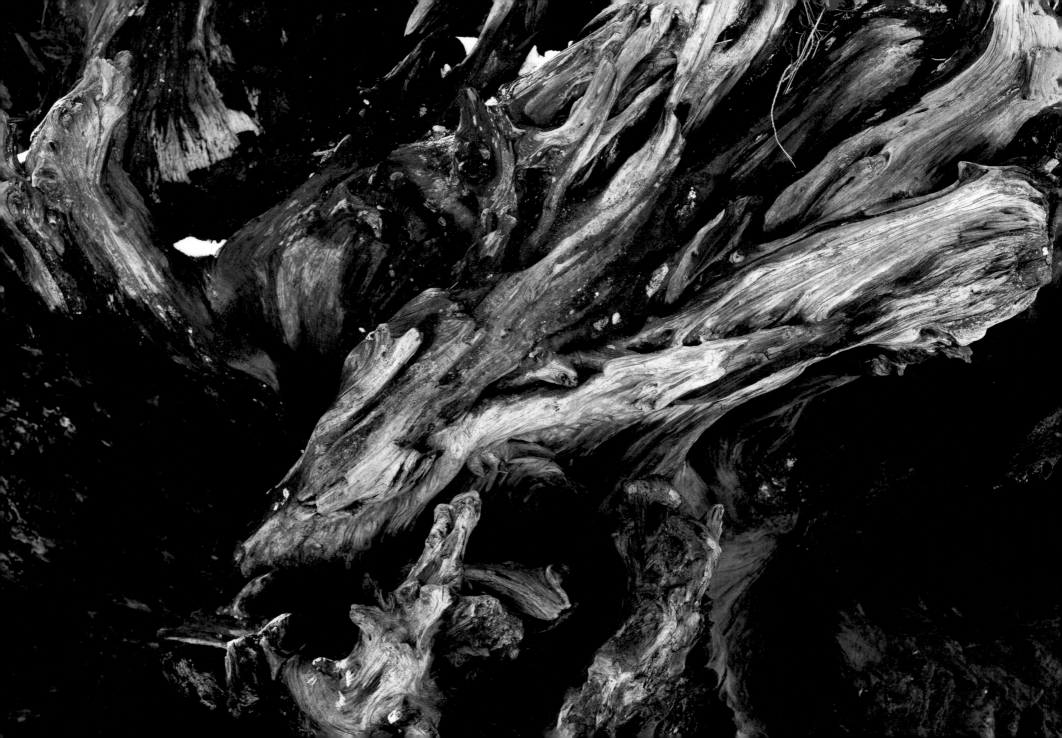

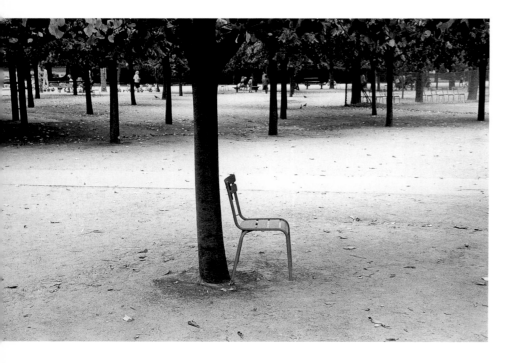

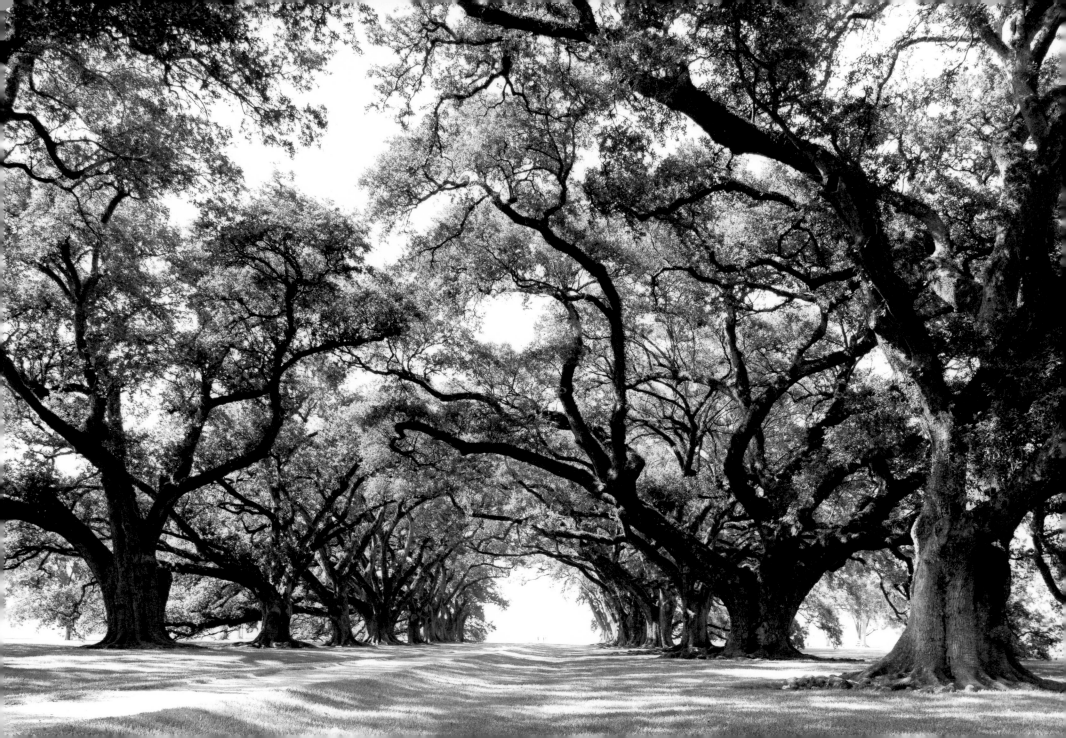

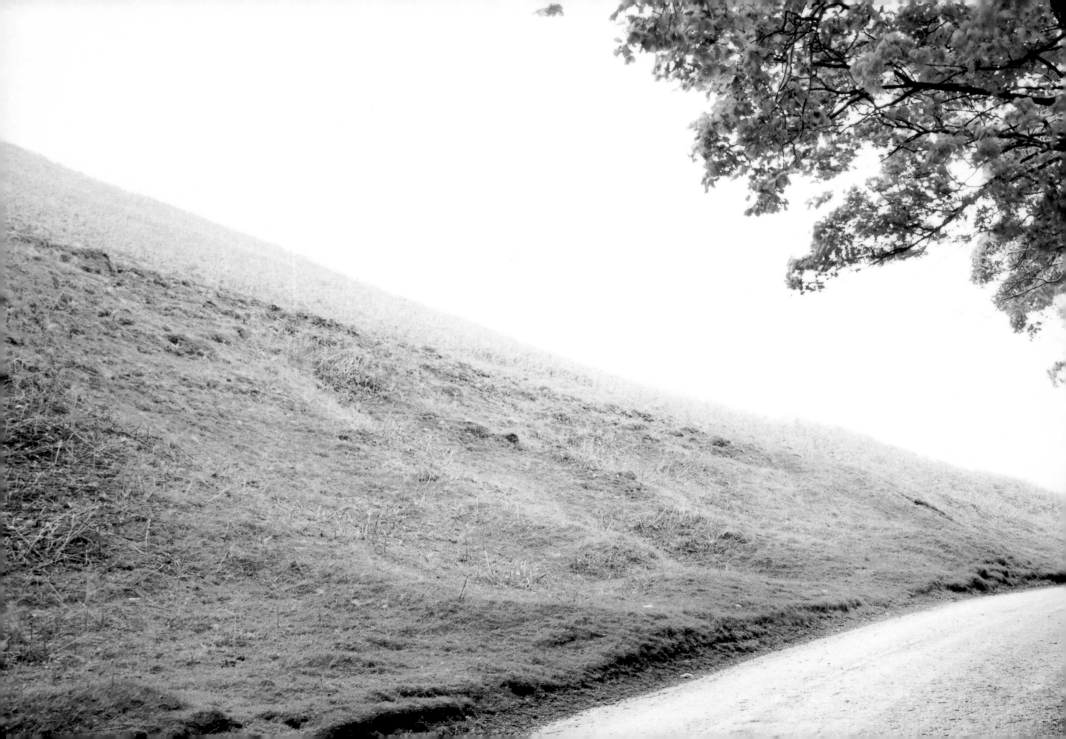

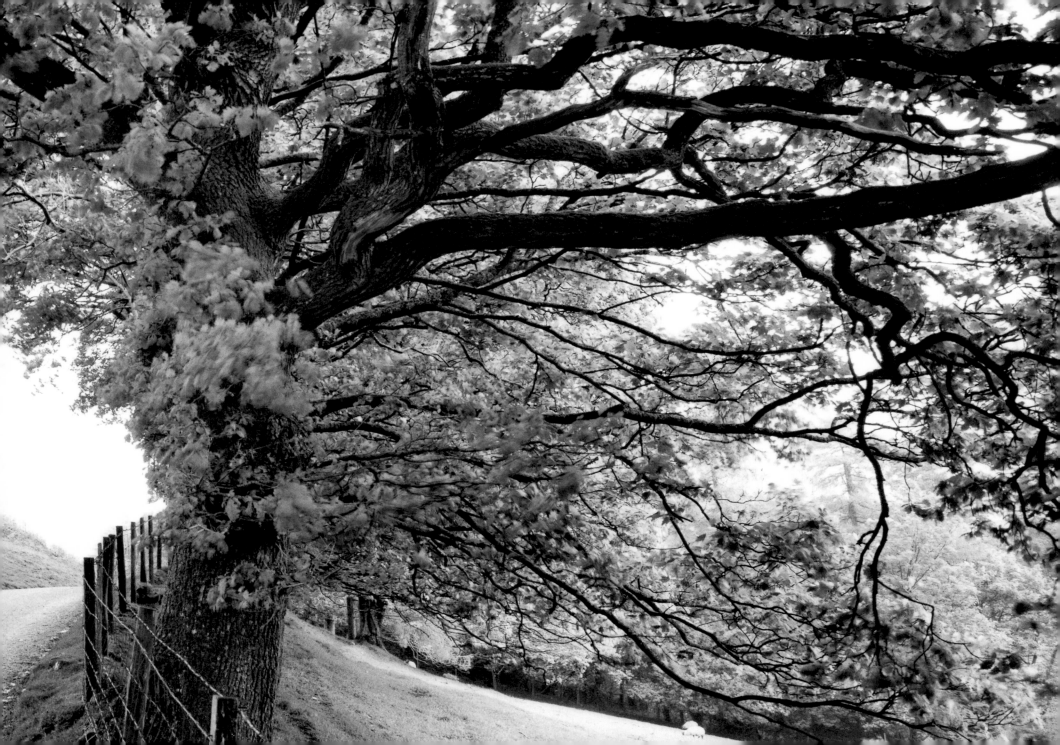

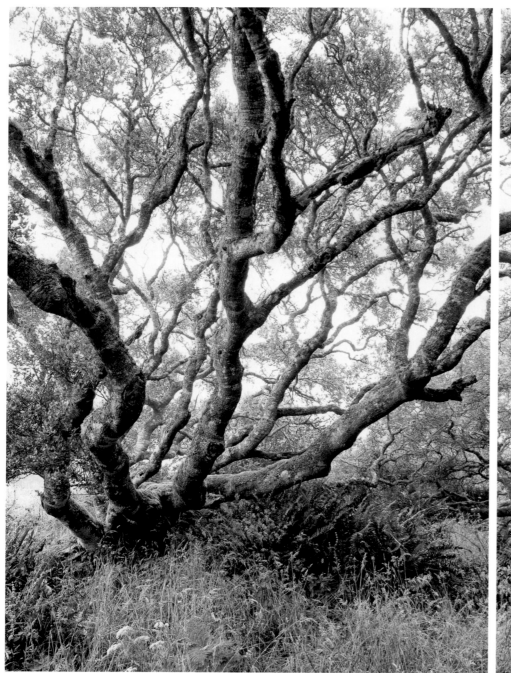

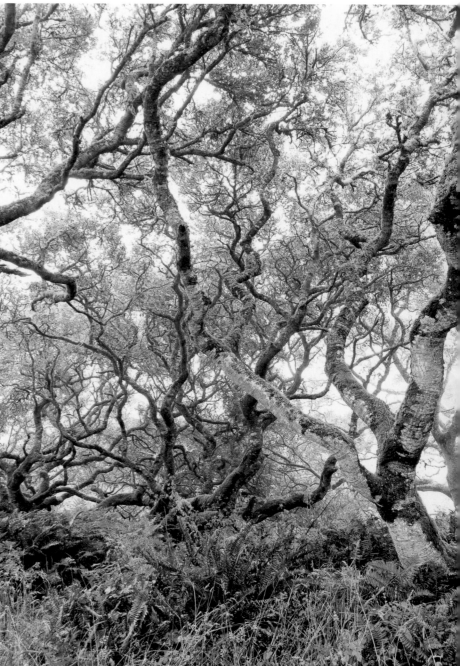

◀ LAKE DISTRICT, ENGLAND

POINT REYES, CALIFORNIA ▲

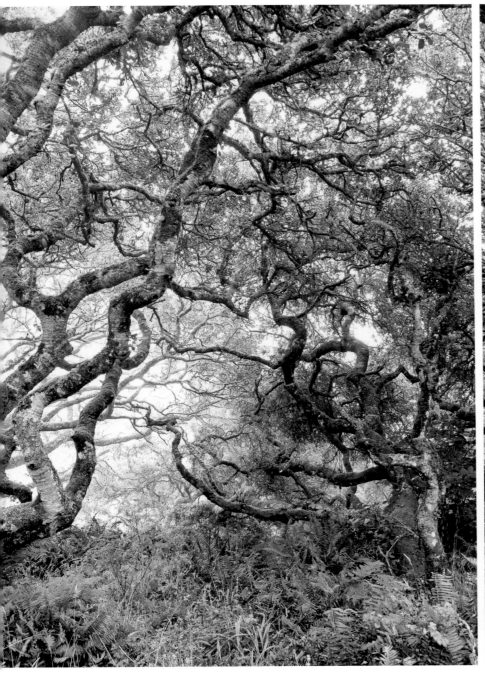
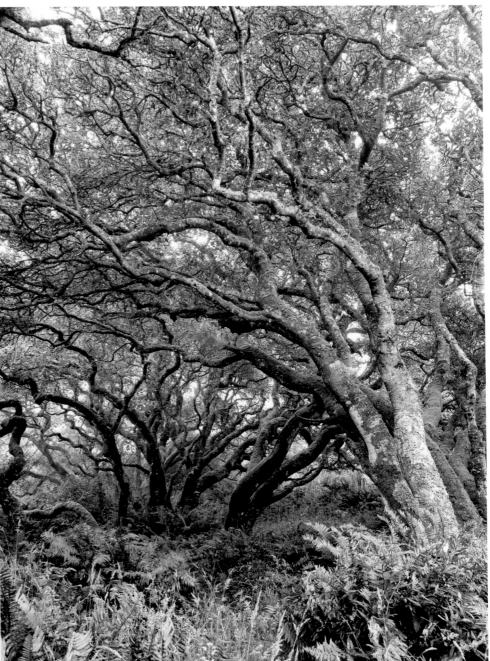

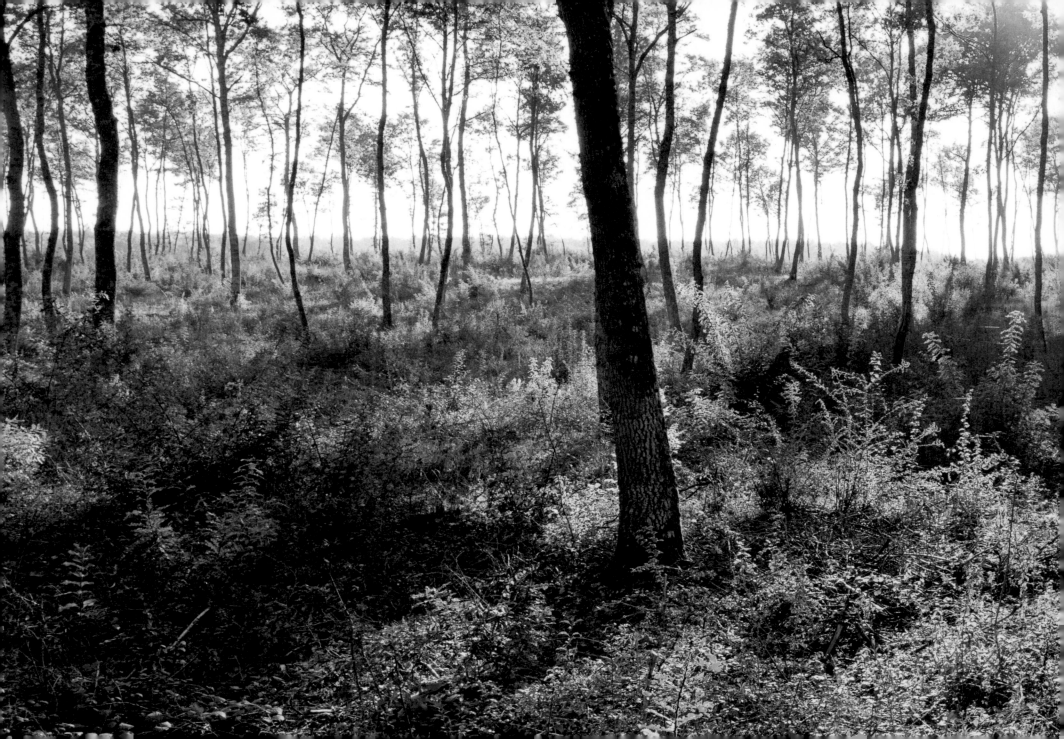

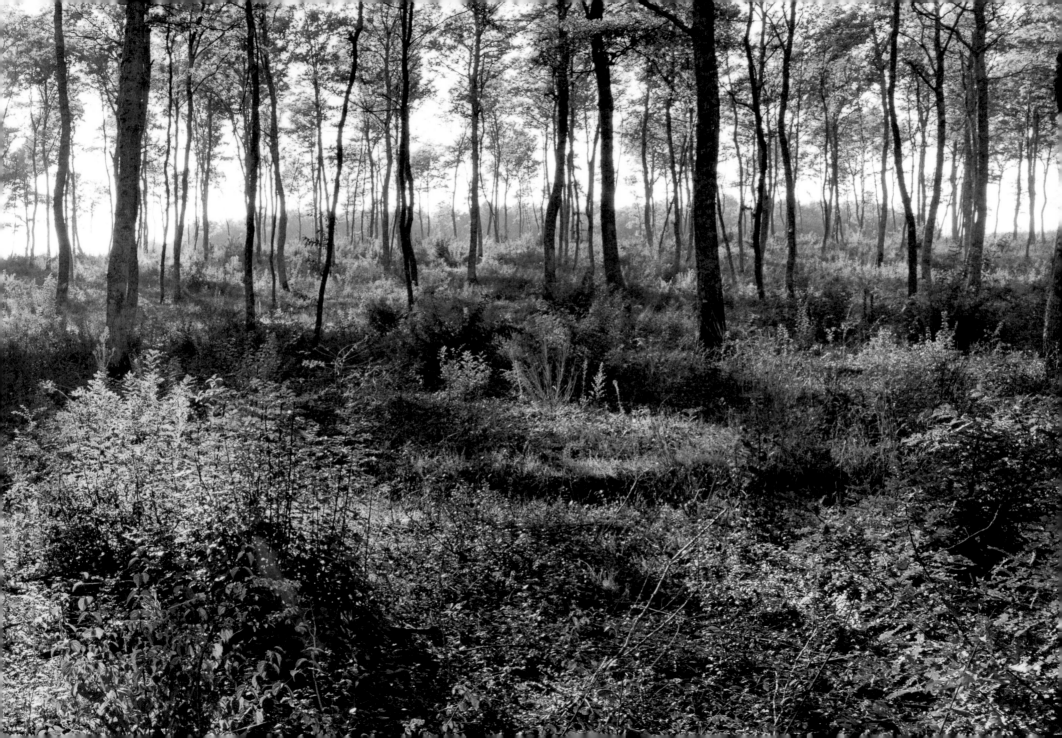

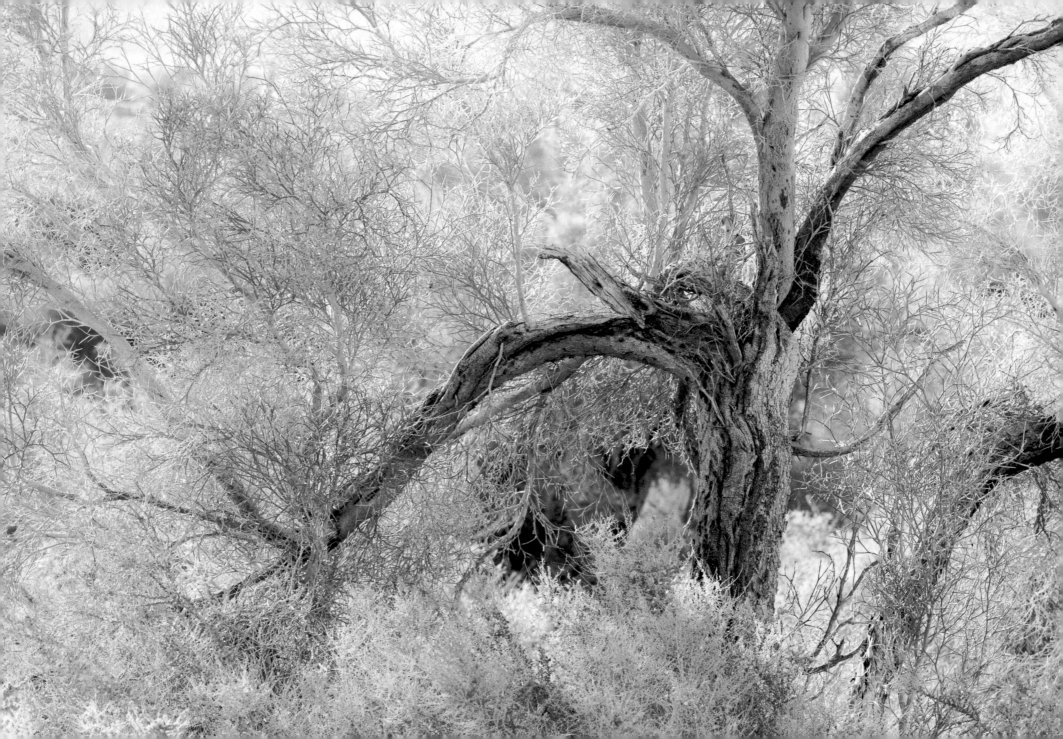

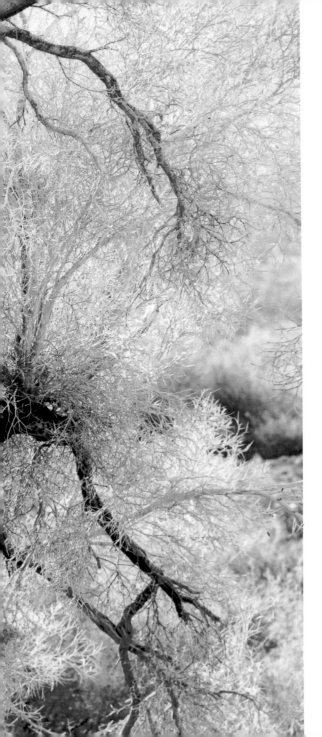

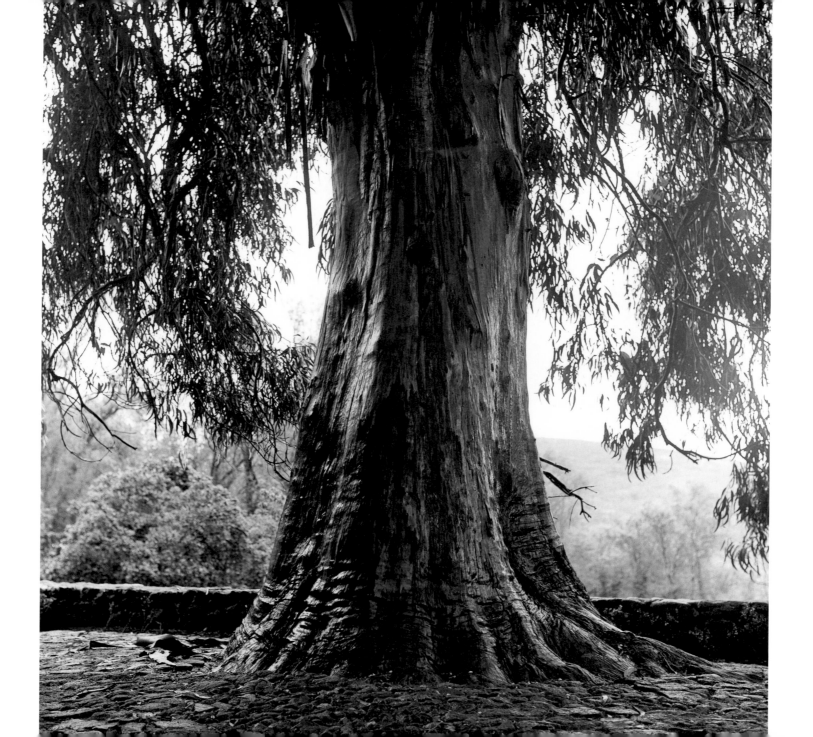

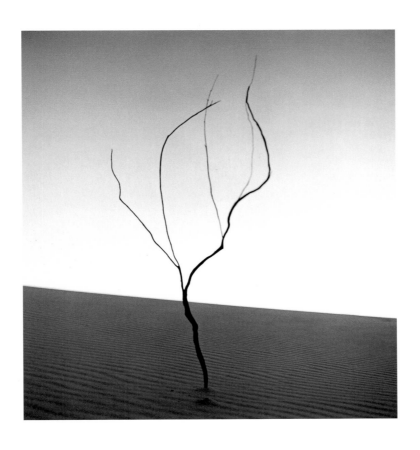

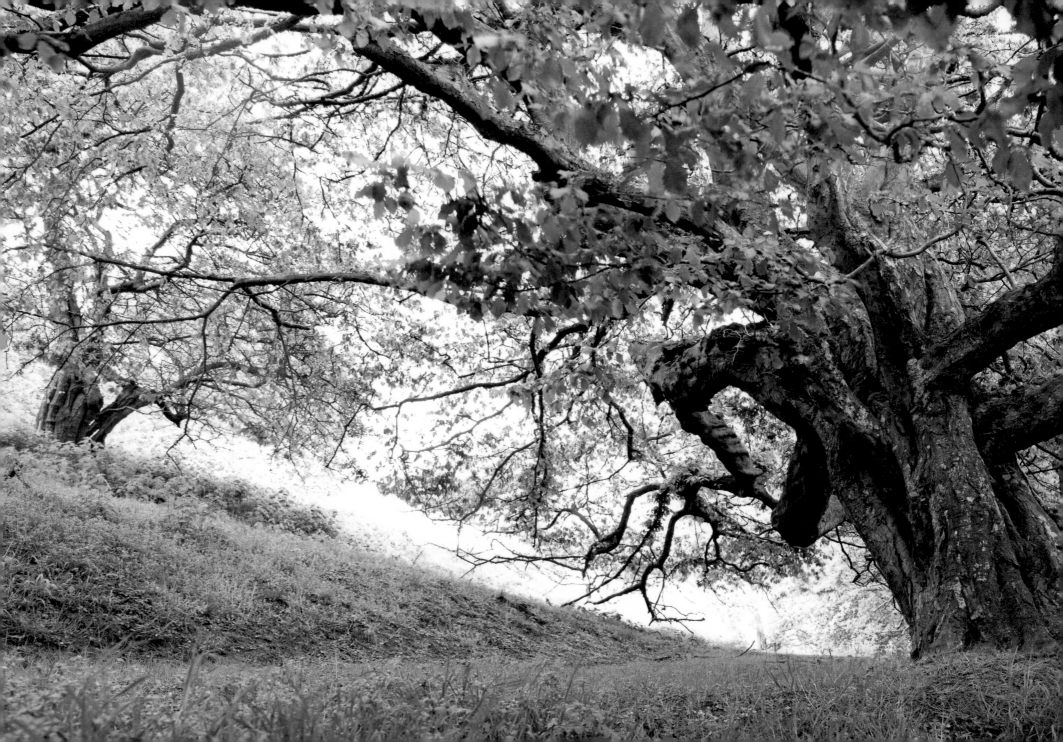

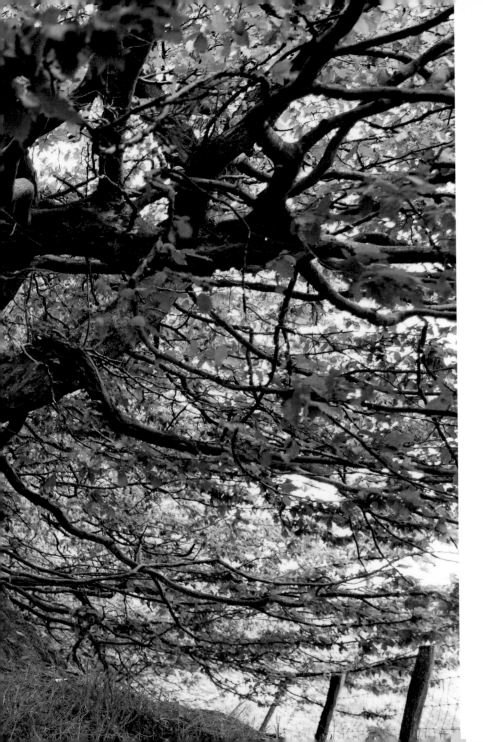

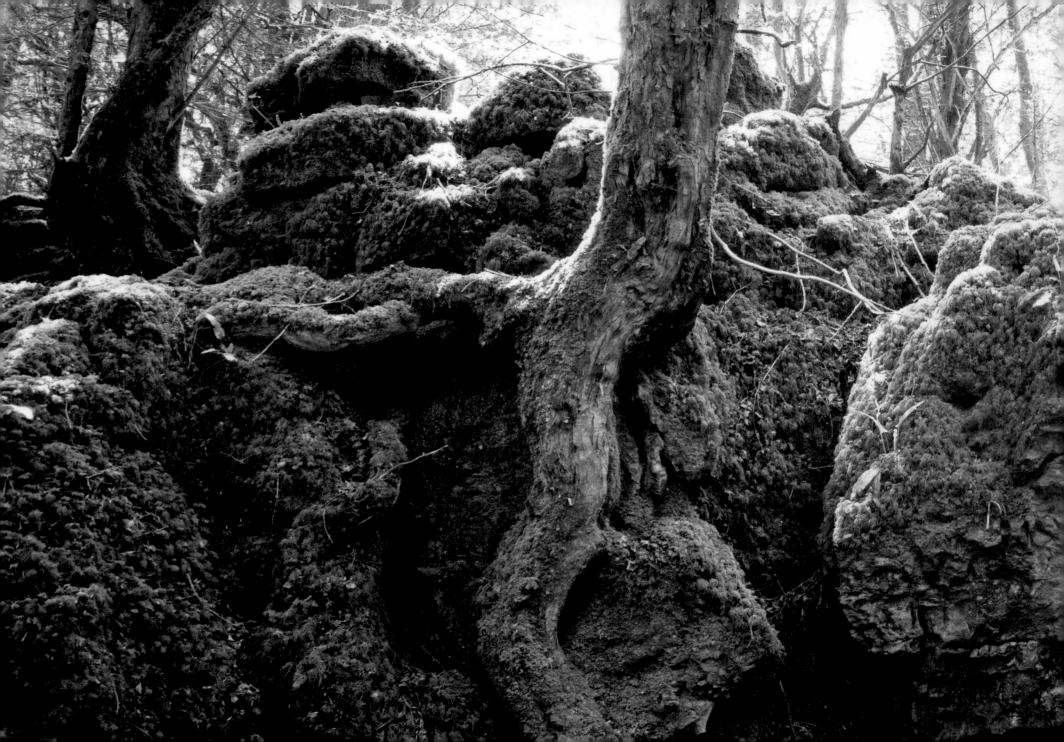

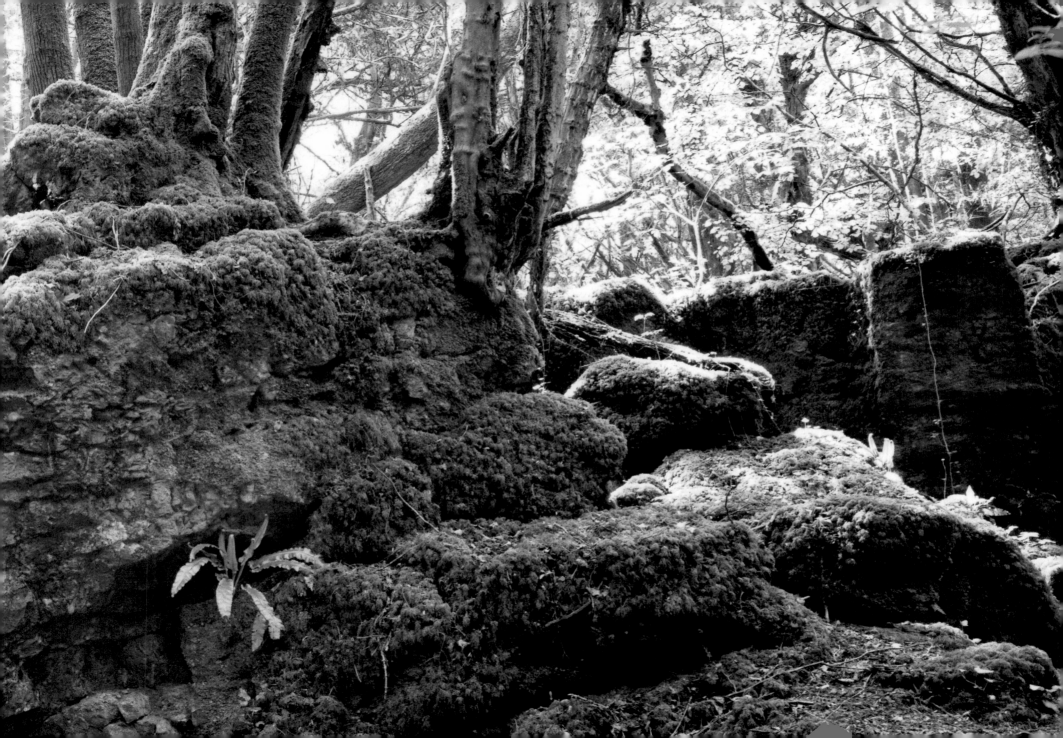

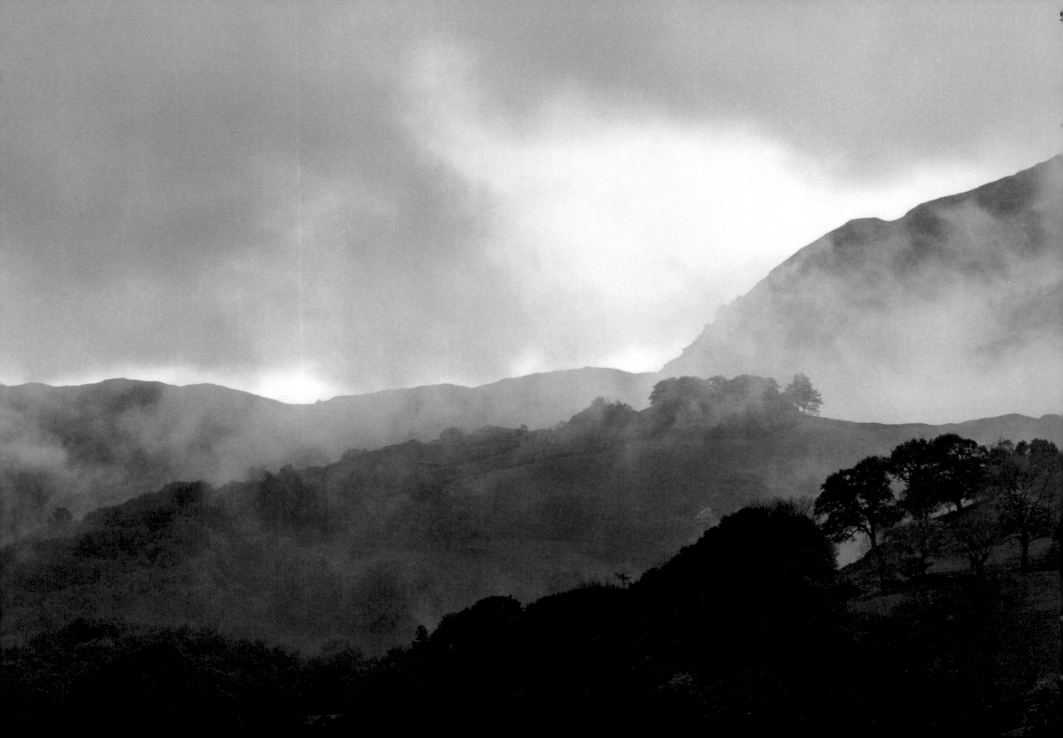

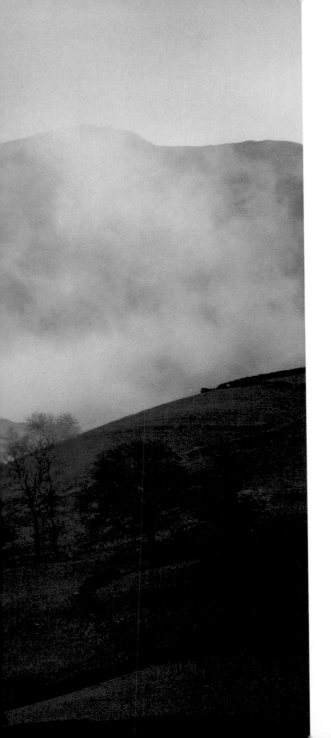

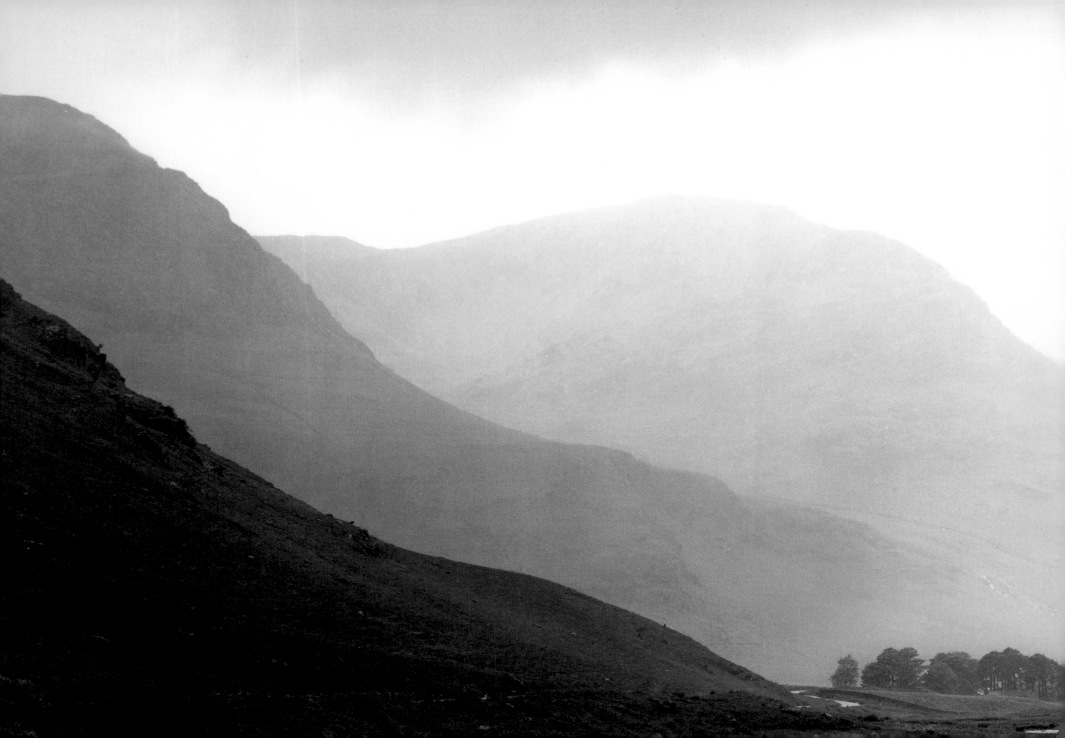

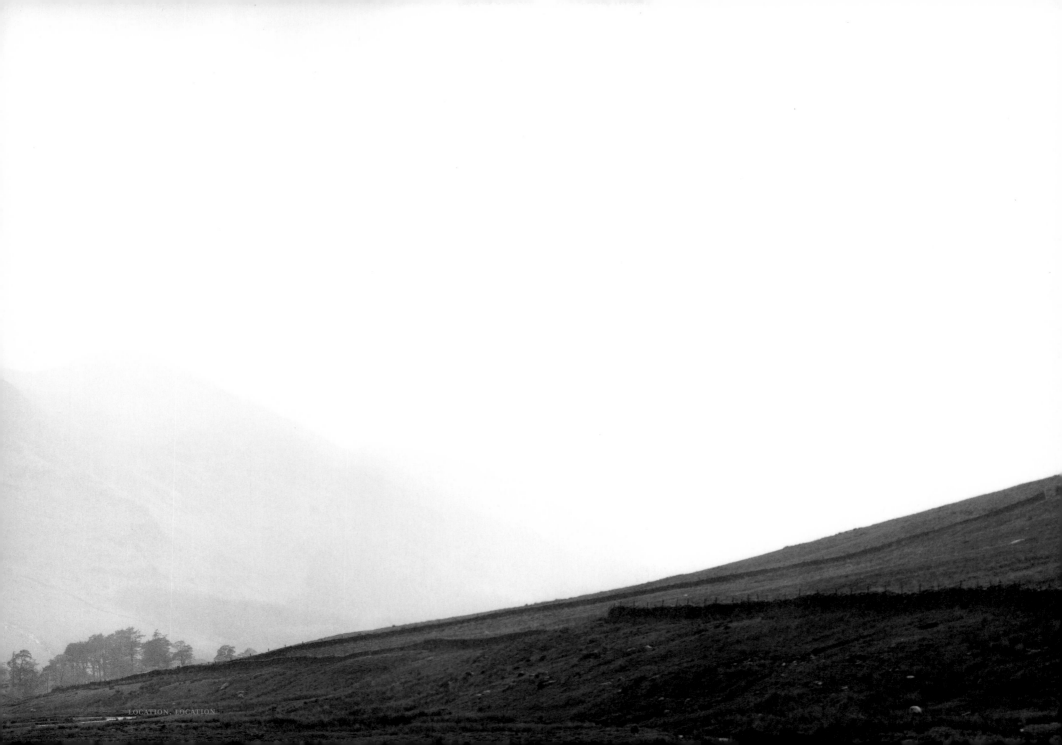

LOCATION, LOCATION

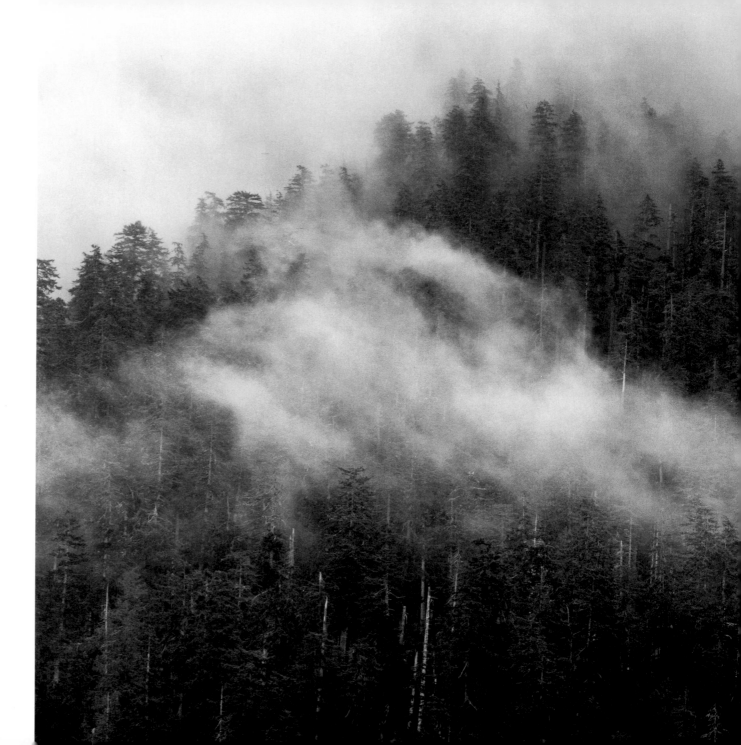

OLYMPIC PENINSULA, WASHINGTON

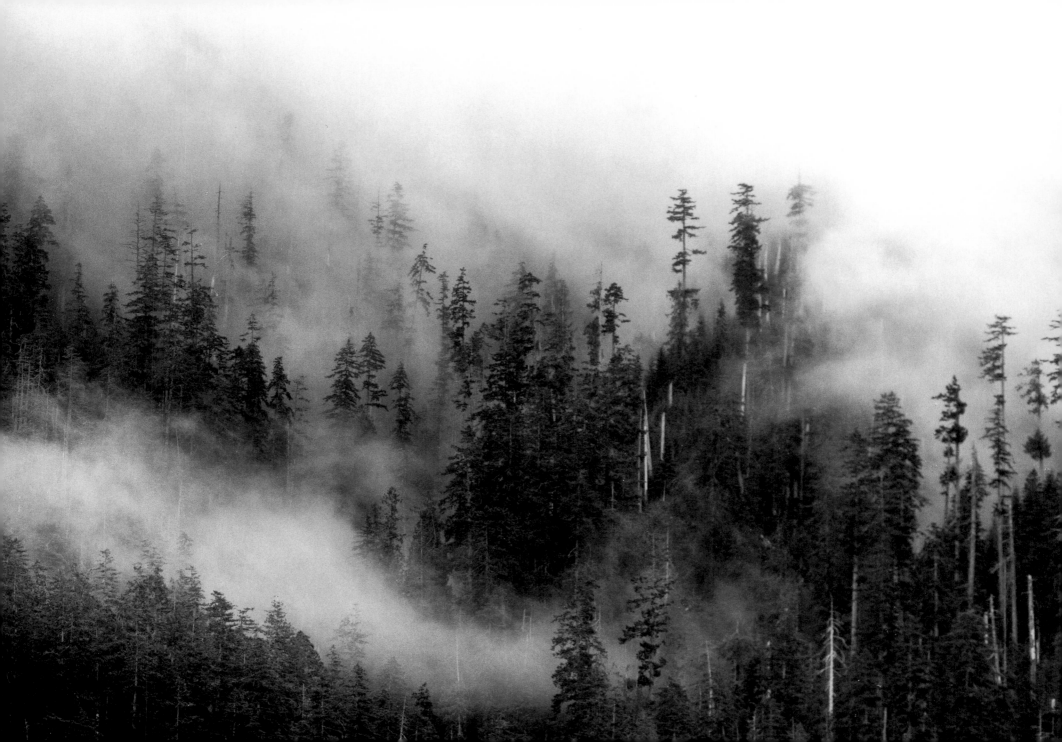

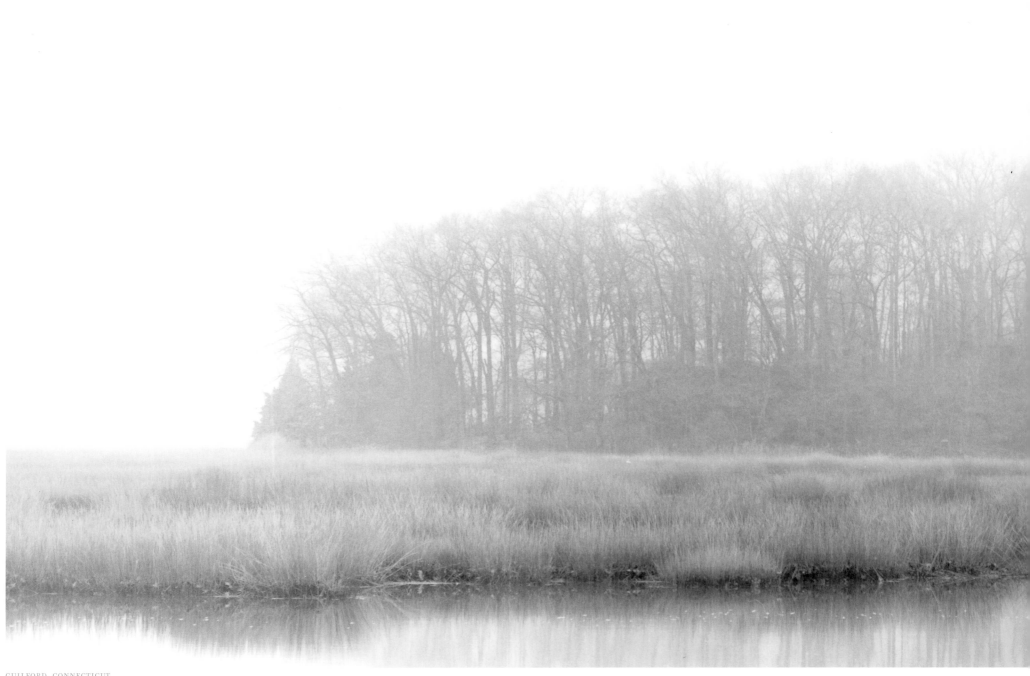

GUILFORD, CONNECTICUT

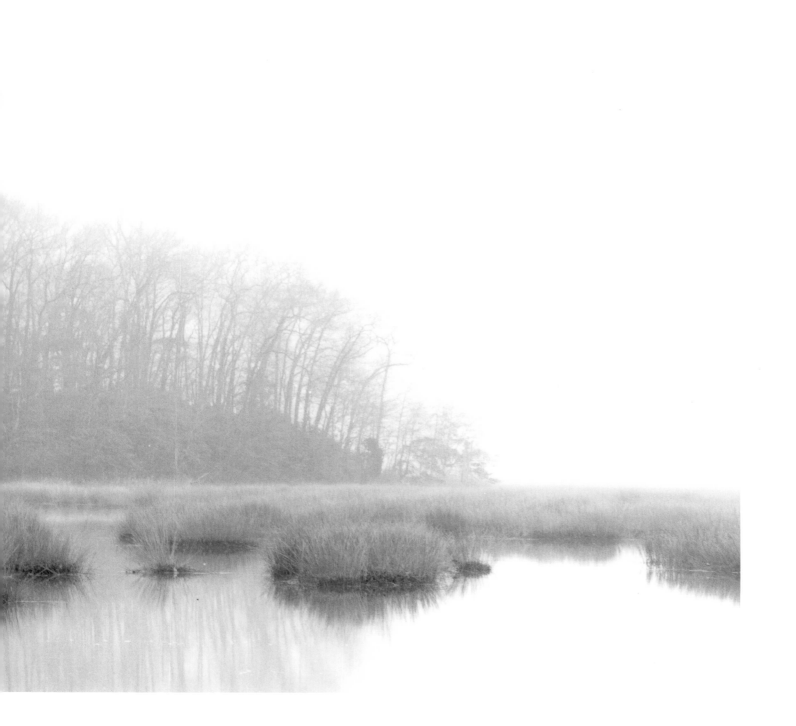

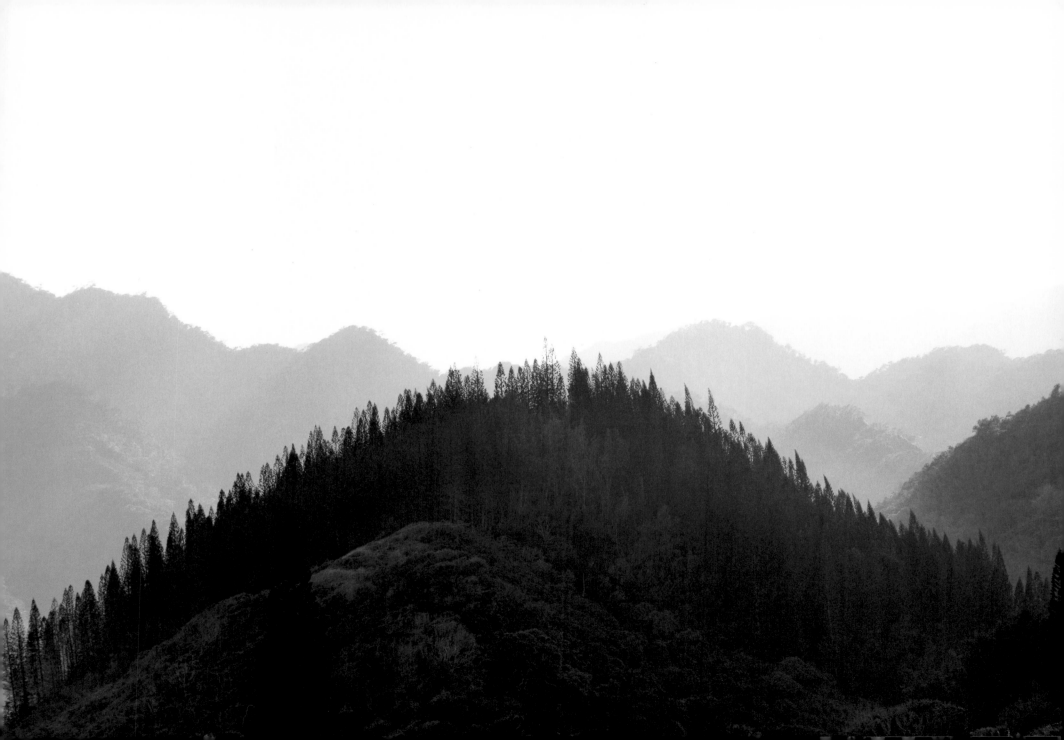

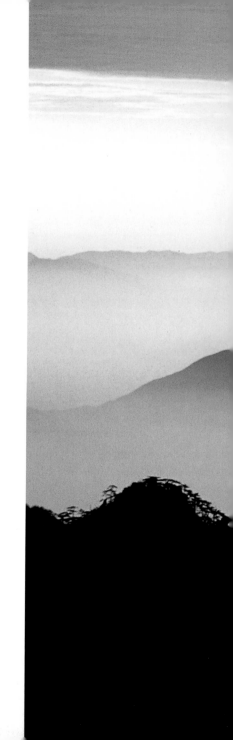

YELLOW MOUNTAINS, CHINA

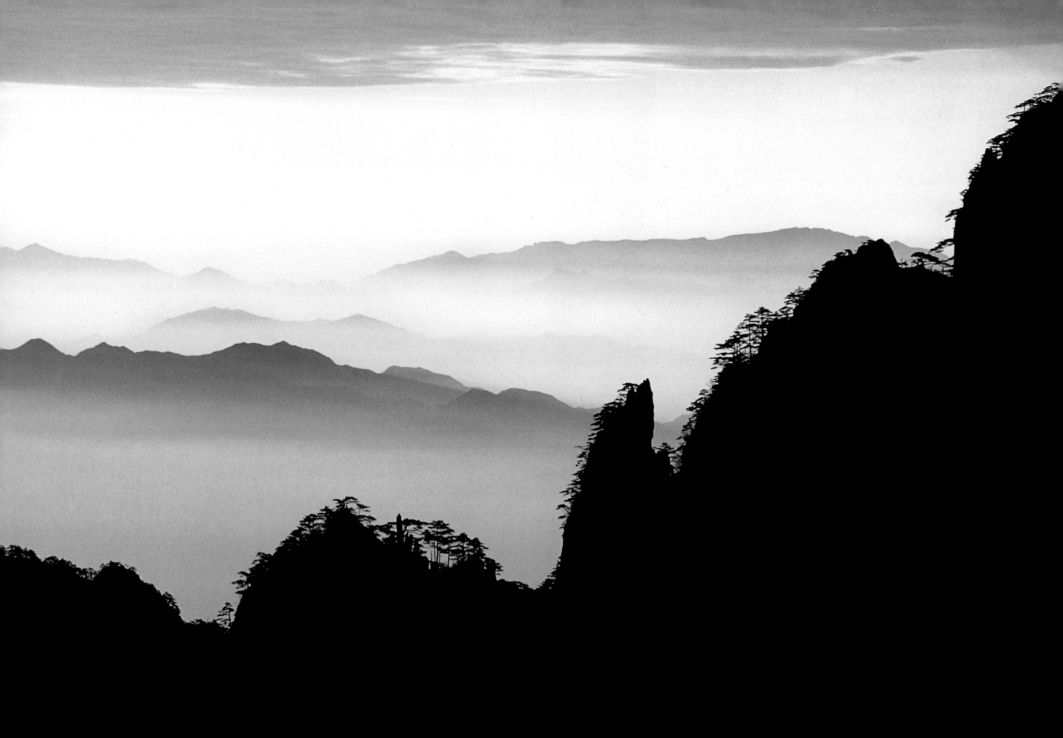

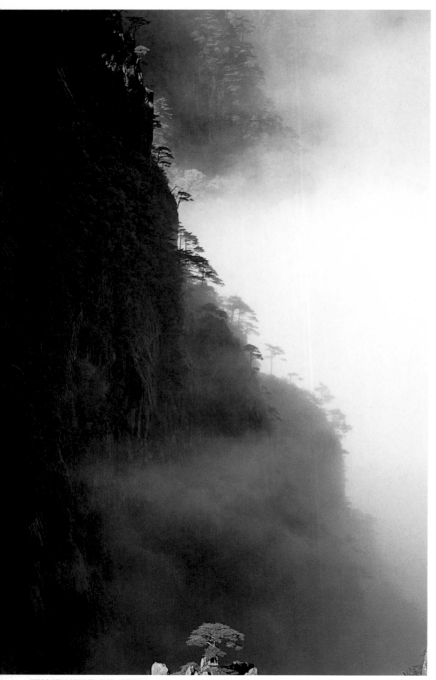

YELLOW MOUNTAINS, CHINA

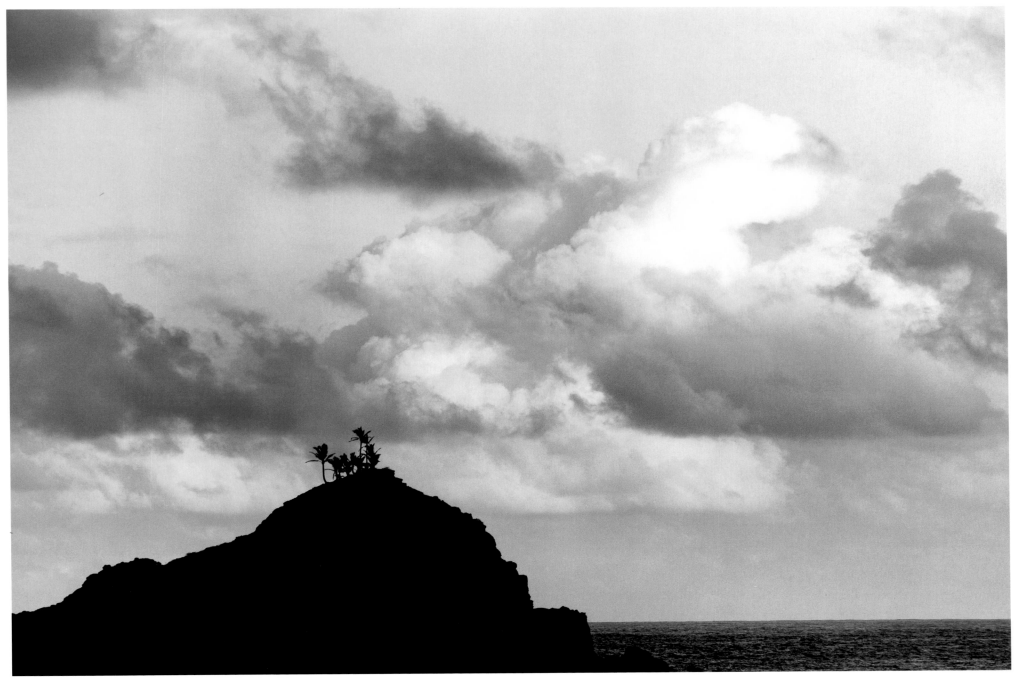

MAUI, HAWAII

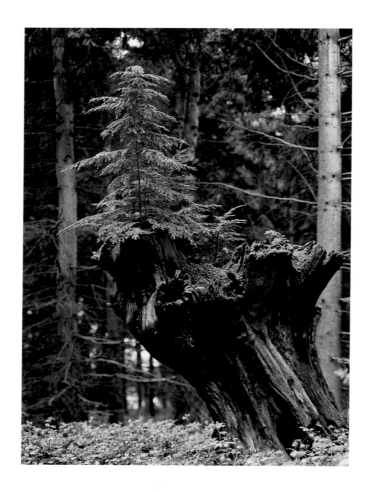

HEREFORD, ENGLAND

Acknowledgments

Thanks to Diane Cook and Len Jenshel, who generously shared trees with me;
to Aris Georgiou, Photosynkyria, Shell (Greece),
and the Sani Festival in Greece; to Raimonda Buitoni in Italy; to the National Trust of England;
to Rosie Atkins in England; to El Monasterio la Soledad in Mexico;
to the owners of Puzzlewood in England; to Leora Kahn at Workman, who called at just
the right time and said, "Do you have a book?";
to everyone at Artisan, who gave me such wonderful collaboration and support—
Ann Bramson, Deborah Weiss Geline, Vivian Ghazarian, Nick Caruso, Nancy Murray, and Amy Corley;
to Les Reiss; to Ngawang Tenzing Gyatso in Darjeeling; to Kim Sibley and Briah Uhl at my studio;
and to my wife, Karen, who encourages me to go.

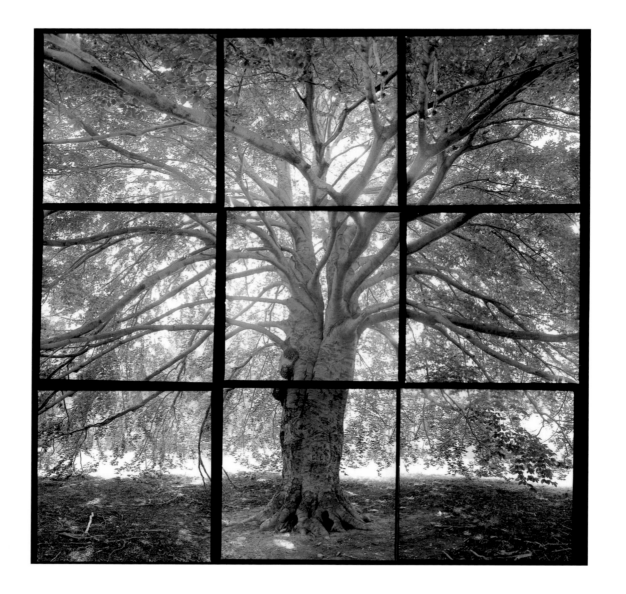

NEW HAVEN, CONNECTICUT